BASINGSTOKE
IN THE 1960S

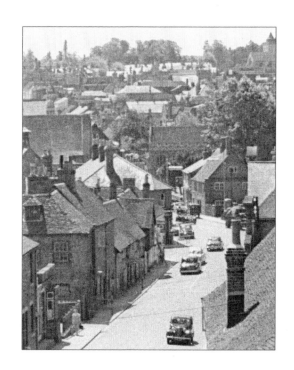

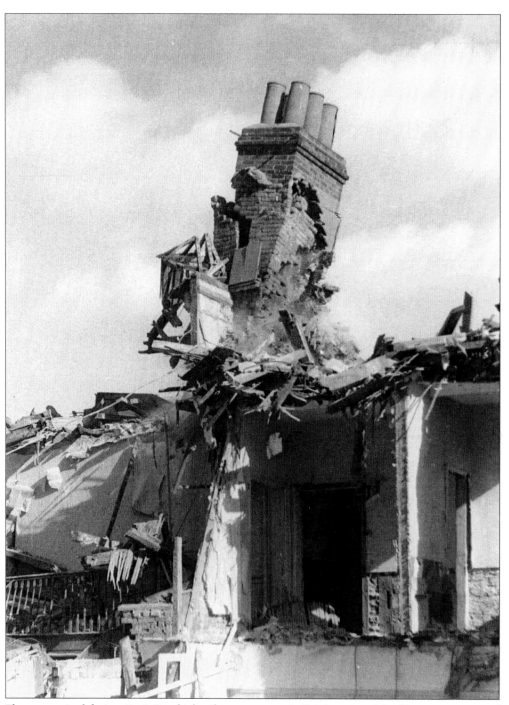

The moment of destruction! Caught by the camera as it disintegrates, this chimney was one of the many that had to come down during the demolition of much of Basingstoke for the Town Development Scheme. The contractor who cleared the area for the massive project was Foster's of Hook, but then Terson's took over after a while using J. & A. vehicles for the demolition. Foster's closed in 1974. Mr Howard Foster, who was in charge of the firm, died in March 1978.

BRITAIN IN OLD PHOTOGRAPHS

BASINGSTOKE IN THE 1960S

ROBERT BROWN

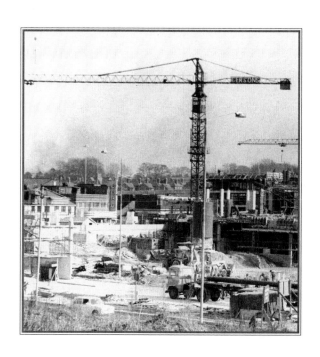

First published in 1999 by
Sutton Publishing Limited

Reprinted in 2010 by
The History Press
The Mill, Brimscombe Port,
Stroud, Gloucestershire, GL5 2QG
www.thehistorypress.co.uk

Reprinted 2011

Half-title page: view across Basingstoke
from the railway station, 1960.
Title page: shopping centre under
construction, late 1960s.

British Library Cataloguing in Publication Data
A catalogue record for this book is available from the
British Library.

ISBN 978-0-7509-1871-7

Typeset in 10.5/13.5 Photina.
Typesetting and origination by
Sutton Publishing Limited.
Printed and bound in Great Britain by
Marston Book Services Limited, Didcot

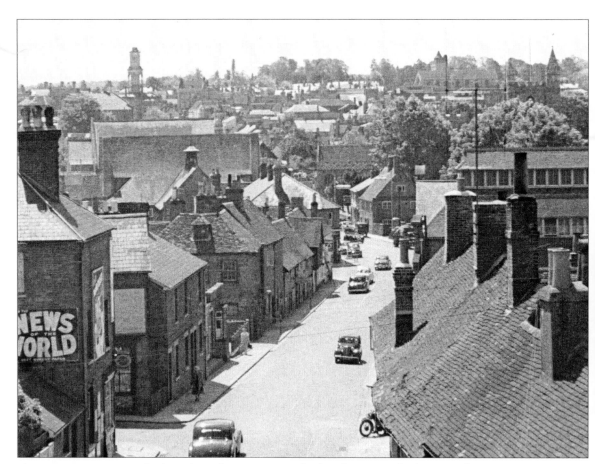

The view across Basingstoke from the railway station, with Chapel Street in the foreground, 1960.

CONTENTS

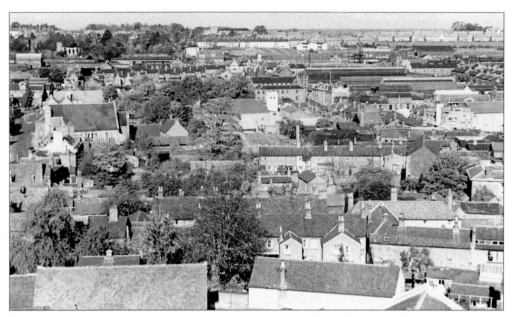

The view across the town centre between Church Street and Wote Street in 1960, showing most of the area that was to be demolished for the new shopping centre. This photograph was taken from the top of the old Town Hall looking towards the railway station. The long roofs on the right in the distance belonged to the factory of Wallis and Steevens in Station Hill.

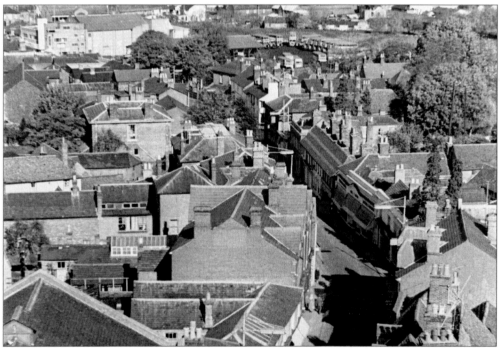

Another photograph taken from the top of the old Town Hall shows Wote Street before that part of the town was torn apart for the new shopping area. The roof at the bottom left belongs to the Haymarket Theatre, which, with a few buildings next to it, just escaped the mass demolition of the mid-1960s.

INTRODUCTION

When people mention the 1960s their thoughts go immediately to the subjects of rock and roll, the Mini, Man on the Moon, President Kennedy's assassination, the beehive hairstyles, the mini-skirt, the Beatles and Dr Beeching's railway cuts. The decade was prominent for its emphasis on the freedom of youth in this country, when teenagers had more money to spend than they had ever had before, with the consequence that they could buy clothes, records, cars, and items that their parents had to save for years to get. The 1960s saw the greatest period of transformation in the social life of Britain in the history of this country. Even house furniture became more modern with lighter materials being used in its manufacture. Between 1960 and 1970 nearly all aspects of life changed and many of the old traditional ways disappeared forever.

In Basingstoke, a small town in north-east Hampshire, 1960 emerged with the rumblings of change just over the hillside, for plans to make it into an overspill area for London were already being talked about in higher offices. The shopkeepers and other business folk, as well as the residents, were becoming anxious about rumours of meetings and agreements at various council halls, and when the news finally broke that Basingstoke's Town Development Scheme had been signed by London County Council, Hampshire County Council and Basingstoke Town Council in October 1961, people realised that the town's way of life was to change drastically in the following years. Its population of 24,500 in 1960 was to double by the end of the decade, because of the massive building programme planned for the area.

Nevertheless, the town continued to live its daily life with its market, every Wednesday and Saturday, outside the Town Hall, and its social calendar still included the annual Carnival Week every July, the meetings of various clubs, societies and organisations, and the gathering of the Vyne Hunt Meet on Boxing Day every year. But by the middle of the decade, as the lower part of the town centre was being demolished to make way for a new concrete shopping centre, then the traditional way of life began to change. Many of the little shops were gone, as well as offices, houses, a cinema, public houses, churches and other buildings, and the local folk found the experience rather traumatic. Some consequently moved away from the town, but others stayed, rehoused in more modern homes on the estates built especially for that purpose, living among the hundreds of families brought down from London to work on the commercial and industrial sites around Basingstoke, which were also constructed under the development scheme.

Basingstoke has seen various forms of change, ever since the first settlers came in the Mesolithic Age (5000 BC). The primitive people of that time moved into the area where Penrith Road was later built. In the Neolithic Age (3200 BC) settlements were made at Kempshott and these have been confirmed by the burial mounds in that area, one of which is in Brackley Way on the Berg estate. The Roman invasion in AD 43 led to the construction of the Roman road between Silchester and Winchester, to the west of Basingstoke, and several Roman villas being built near the town.

Throughout these invasions and settlements the town was slowly taking shape. Another intrusion into the lifestyle of the local folk was the coming of the Danes, whom King Alfred fought against in the ninth century. In 1086 the Domesday Book recorded that Basingstoke was a royal manor but had never paid any taxes. It also had a market and a church, two items that confirmed it was an established community. From then on Basingstoke grew slowly until the seventeenth century when Cosimo, Prince of Tuscany, Italy, recorded while on his European tour that Basingstoke was a wretched place and lacked any trade. He did not know that the town had experienced a serious fire, the Civil War and the Plague in the previous few years.

Daniel Defoe, the author, was to record a different picture many years later, in 1724, when he wrote that Basingstoke was 'a large populous market town' and that it 'has a good market for corn'. By the end of the century the construction of the Basingstoke Canal between the town and the River Wey in Surrey had brought a great deal of trade into the area, and by the 1830s all sorts of goods were being transported by barges along the waterway. But then the railway was built in 1839 and brought this all to a halt, until the same goods began to be sent by rail between London and Southampton and returned trade to Basingstoke. Within twenty years the town saw an increase in its number of businesses, and soon large factories, such as Wallis and Steevens in Station Hill, the agricultural engineers, set up trade in the town. The arrival of Thornycroft's factory, where motor vehicles were manufactured, in 1898 brought an increase in the population and the growth in size of the main town.

By 1960 Basingstoke had acquired several housing estates, such as South Ham, Southview, Oakridge, Harrow Way, and the Berg, while commercial and industrial sites had already been established before the Town Development Scheme had been implemented. The shopping area, of Winchester Street, London Street, New Street, Church Street and Wote Street, with Potters Lane and Cross Street, was a busy place, but the motor car was a problem! There were few places to park, and the plan to bring London's overspill into the town meant that a drastic transformation had to take place. And so the mass demolition and development began.

The intention of this book is to bring into focus life in Basingstoke during the 1960s, with pictures taken by me during that period. It is not a complete record, but merely a guide to the general way of life in the town at a time when so much change was taking place both locally and nationally. The information in the captions and introduction has come from research into the history of Basingstoke, and various interviews with people over the past fifty-five years. I am very grateful to them all for their help in bringing this book into production. Thank you.

Robert Brown

CHRONICLE OF THE 1960S

1960 Worting Road Technical College built at a cost of £211,450.

One-way road system begun in the town centre, involving Winchester Street, London Street and Southern Road. Other roads later involved.

1961 The Basingstoke Town Plan was issued after a similar plan for Hook village was abandoned. In October an agreement was signed to expand the town. The Town Hall clock tower was dismantled after being found to be unsafe.

The Worting Road Municipal Caravan Site was established.

1962 28 June: New bus station opened on a 6½ acre site off lower Wote Street. British Restaurant premises demolished in lower Wote Street. Jackson's Garage was built on the site.

The Wilts and Dorset bus depot in Victoria Street closed down.

Proposals to develop Basingstoke were revealed to the public.

1963 The London Road Court House was built and opened.

Further expansion of the South Ham estate led to shops, schools and churches being built in the area.

1964 The Carnival Hall in Council Road built and opened, from funds from the carnivals of previous years.

The expansion of Basingstoke took place during the year involving the construction of housing and industrial estates.

The Ring Road was begun.

The Riverdene private estate was built.

1965 Sainsbury's factory at Houndmills erected, with other factories and offices.

17 October: The last service was held at the Church Street Methodist Church prior to its intended demolition, with other buildings, for a New Town centre.

The population of Basingstoke was reported as 33,000.

1966 Cranbourne Lane council houses demolished.

Freedom of the Borough presented to the Hampshire Regiment.

4 May: The Cattle Market, in operation since 1873, closed down.

Chineham Farm and Buckskin Farm acquired for town development. The large Popley housing estate was started.

The town centre was demolished between Potters Lane and the railway station.

1967 Construction began of the New Town centre and multi-storey car park.
The railway line between Basingstoke and London was electrified.
The Conservative Club opened new premises in Bounty Road.
Work began on the construction of the Basingstoke Hospital in the grounds of Park Prewett.
London Road police station opened.
Cranbourne School erected.
New fire station opened at West Ham.

1968 Thornycroft's became part of the Leyland Motor Corporation.
Alfred Cole dumped several lorry loads of earth in the centre of the town in protest at the compulsory purchase of his Eastrop land.
RAF Odiham received the Freedom of the Borough.

1969 Black Dam ponds partly filled in by roadworks.
Demolition of the old Workhouse buildings in Basing Road.
New Basingstoke Library opened by Rt. Hon. Harold Macmillan.
The first stage of the Basingstoke Hospital was opened.

1970 The Sports Centre was opened by the Duke of Edinburgh.
The Trinity Methodist Church in Sarum Hill was opened; old church demolished.
Eastrop Rectory was demolished and a new one was built close by.
M3 motorway constructed.
John Hunt of Everest School at Popley was opened.

CHAPTER ONE
1960–1961

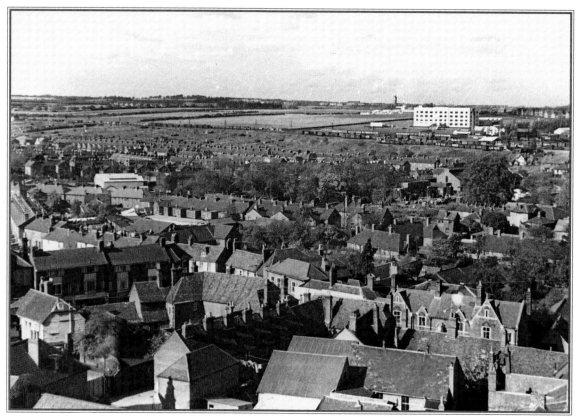

The view across Basingstoke from the old Town Hall clock tower, looking towards Eli Lilly's factory and the railway, 1960. The buildings in the centre of this picture were to be demolished to allow Timberlake Road to be built, while the fields in the distance were to be built upon for industrial and commercial purposes.

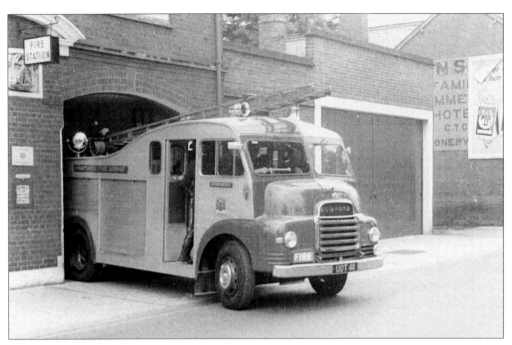

The Brook Street fire station, with one of the fire engines leaving to head for a fire. When the station was built in 1913 one motor fire engine was provided at a cost of £865. The acquisition of the land and construction of the station cost £1,235. When the site was compulsorily purchased for the New Town centre in the early 1960s a new and larger fire station was built at West Ham.

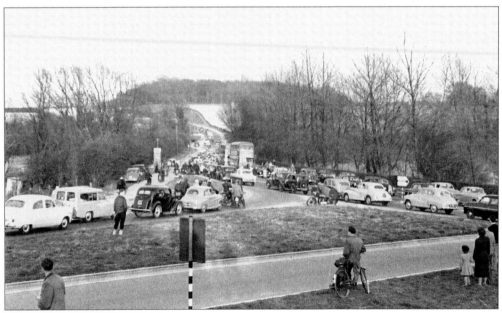

The joys of motoring in the 1960s were mixed with patience in the Basingstoke area at holiday time, especially when the traffic entering the London Road from the north and west at Black Dam ponds led to chaos, such as that seen here. Local folk would walk down through the Basingstoke Common to see the annual snarl-up, especially at Easter when home-going traffic on the evening of the Monday would trail along the A30 road for miles.

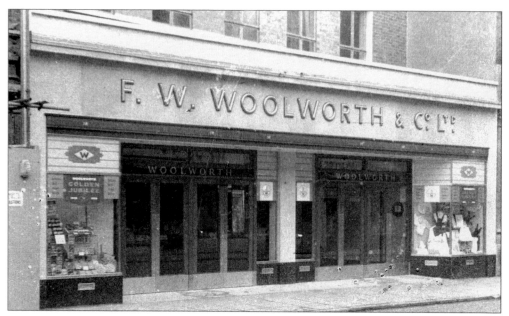

Before the main High Street stores and shops moved into the new shopping centre they were situated in various roads at the top of the town. F.W. Woolworth and Co. Ltd was one such, seen here on its original site in London Street where it was established back in 1921. When the lower section of the new shopping centre was opened in 1970 Woolworth's moved to a prime site with larger premises. Woolworths was to close down in 2008, when all its other branches were closed across the country. The London Street site became the main Post Office for Basingstoke

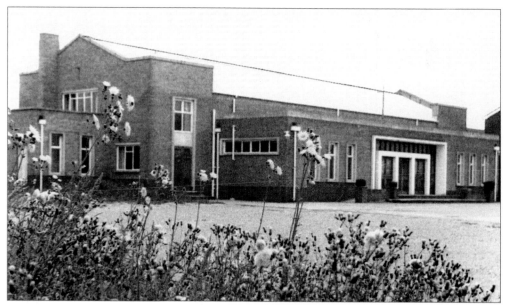

St Joseph's Hall in Western Way was built and opened in 1959 for the Roman Catholic population on the South Ham housing estate. The building was used for both religious services and social occasions, and was hired out for other purposes as well, such as dances. The building was demolished in 1987, after a new Roman Catholic church was built in St Michael's Road. The Western Way site was used for the erection of homes, called Carpenter's Court.

After the Berg estate was built on land between the South Ham estate and the Down Grange land many of the residents were far from satisfied with the choice of shops built in Buckland Avenue. By 1960 a promised chemist's shop had not been opened, so many of the people on the estate made a public protest in front of the site office in High Drive, as seen in this picture. (The chemist's shop has never materialised.)

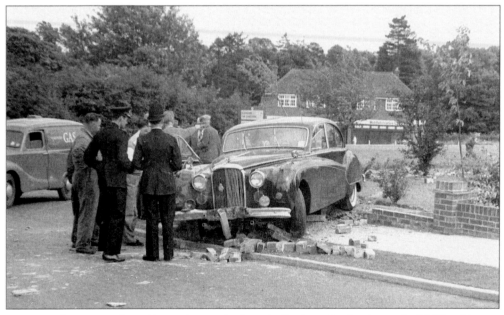

Just one of many road accidents that took place in Basingstoke in the early 1960s: this one devastated a garden and knocked down a road sign and two walls. It occurred after a Bentley careered off the Basingstoke bypass and finished up in Sheppard Road. No one was injured, but it left the car a bit dented.

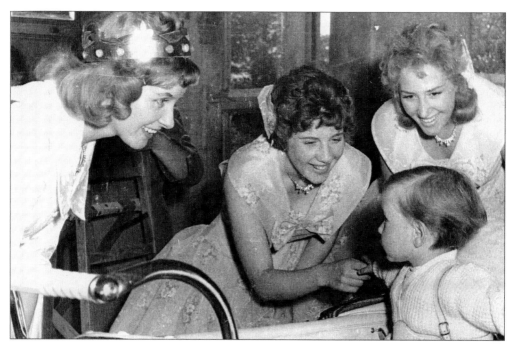

One of the most attractive Carnival Queens of the postwar carnivals in Basingstoke was Althea Preston (left), who was selected in 1960. Of the seventy-three entrants for the competition her card number was 13 – lucky for her! One of the many places that she and her retinue went to was Audleys Wood old people's home, and here Miss Preston and two of her retinue meet the owners' young child.

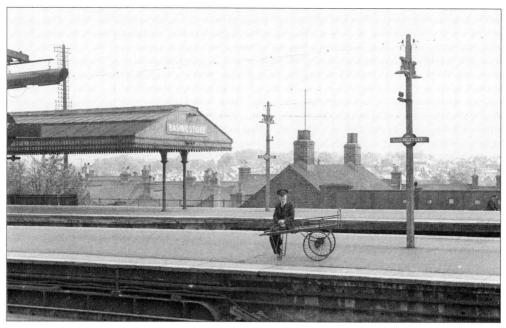

In days of old the Royal Mail travelled by train all over the country, but by the late 1960s decisions were being made to dispatch it by road from town to town. In 1960 Basingstoke post office still collected from the railway station, and here a single postman, Jock Harvey, awaits the next train to arrive with mailbags for his office.

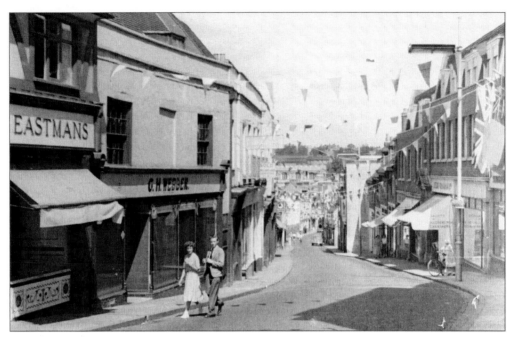

Carnival week would bring out the flags and bunting in the town centre, such as here in upper Church Street. The two shops in this picture were representative of the many small shops in the town: Eastmans was a butcher's, which was one of some ten in Basingstoke; while G.H. Webber's was a draper's shop, established in 1896. Both shops were to close down upon the opening of the new shopping centre.

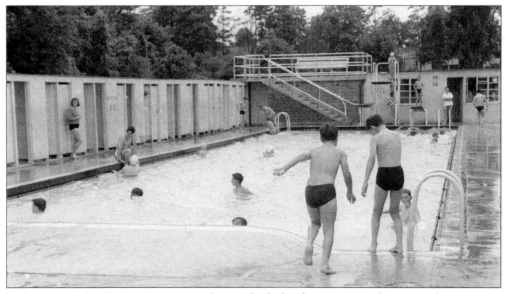

Back in 1906 the West Ham Waterworks was built for the ever expanding town, because of a typhoid epidemic caused by a leak at the Reading Road works. At the same time as the waterworks was being built it was decided to construct a public swimming pool, which proved very popular. Exactly sixty years later it was closed, as it lay in the way of the ring road to the west of the town. The construction of the Sports Centre swimming pool and the pool on the West Ham entertainment site in the late 1960s made up for its closure. This picture shows the old pool in 1960.

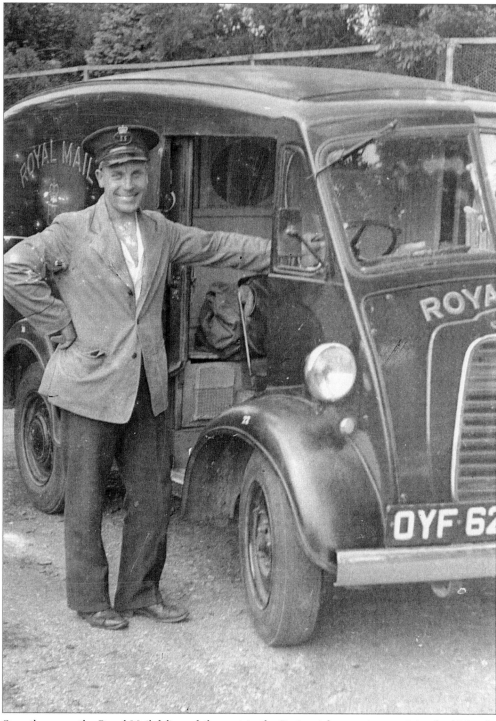

Over the years the Royal Mail delivered the post in the Basingstoke area in a variety of vehicles. In the 1950s and '60s one type was this Morris van with a curved roof. Known as the 'Snub-nose' van, it was the first van to have tubeless tyres, and another feature was its rubber mudguards. Standing by the side of it is Kenneth Sole, one of the local postmen at that time.

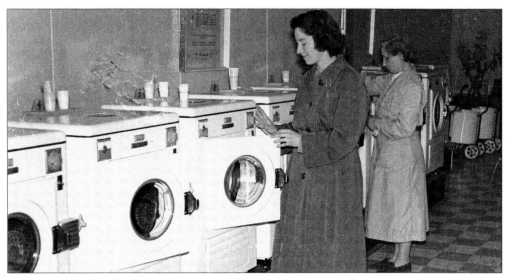

When washing machines were first produced in large quantities they were a luxury item which not many people could afford, so launderettes opened up in various towns to allow the public to wash their clothes at a small fee. All that was needed was soap, the clothes and a coin, and a certain amount of patience or a good book while waiting for the machine to stop. A launderette was opened in London Street, opposite the Deane's Almshouses, and survived right through to 1980 when it closed. Operating one of the machines is Mrs Hilda Goddard (front).

In 1960 the shopping centre consisted mainly of small shops kept by local people, and in this picture of upper Church Street some of those shops can be seen lining the road. In the distance is the Town Hall clock tower which was to be dismantled, because of structural weakness, in 1961. The parade in the street was part of the annual Mayor's Parade and Service, which took place every May after the inauguration of a new mayor.

Television personality Sheila Tracy opened a fête at the Shrubbery Secondary School in Cliddesden Road, and then proceeded to take part in the various amusements. Sheila Tracy was a former trombonist with the Ivy Benson Band who went on to be involved in various radio and television programmes. She also devised the Truckers' Hour on Radio 2. Miss J. Mears, the Headmistress, accompanied her as she went from stall to stall. The Shrubbery School later changed its name to Queen Mary College.

By 1960 several of the town's private housing estates were already under construction, including Harrow Way (pictured), which was being built between Cliddesden Road and the bypass. The increase in commercial and industrial businesses in the town was bringing more and more people to Basingstoke, and they needed somewhere to live. With the Berg estate almost completed along the Winchester Road, and the Clarke estate at Winklebury (where houses were to be sold from £2,000) about to be built, there were plenty of homes for those wishing to buy.

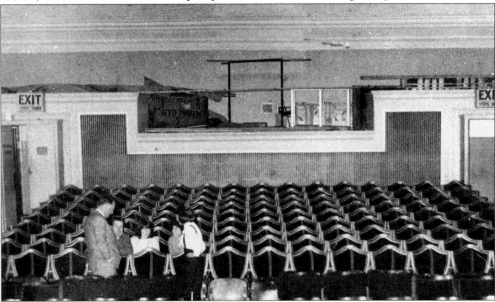

The Haymarket Theatre in upper Wote Street was originally a corn exchange (built in 1865), then later a cinema and a theatre. In this picture, taken from the stage, the rear of the auditorium where the projectors were situated can be seen. The building was gutted by fire in 1925 then rebuilt. It was renamed 'The Haymarket' in 1950 and since then has been considerably altered and extended.

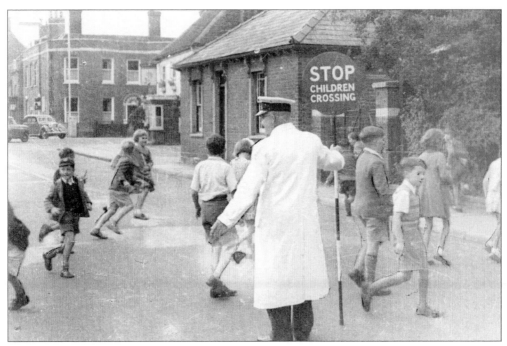

A school patrolman, known nowadays as a 'lollipop man', helps the children from St John's School to cross Brook Street, where the youngsters used to leave the building. In the background is the crossroads of Brook Street with Chapel Street and Church Street.

Before the old British Restaurant building, on the corner of Wote Street and Reading Road, was demolished in 1962 the local group of the Salvation Army held regular meetings there. Their headquarters further along Reading Road, which was built in 1883, closed down in May 1976 when the Salvation Army moved to Wessex Close.

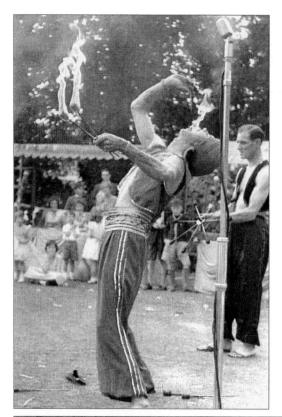

During the 1960s the annual Rectory Fête continued to be held in the grounds of St Michael's Church rectory, in lower Church Street, where an assortment of amusements and stalls was provided. In 1961 a fire-eater and sword swallower provided further heat on a hot July day. The fêtes were begun in 1905 after the Revd Harry Boustead became vicar of St Michael's Church.

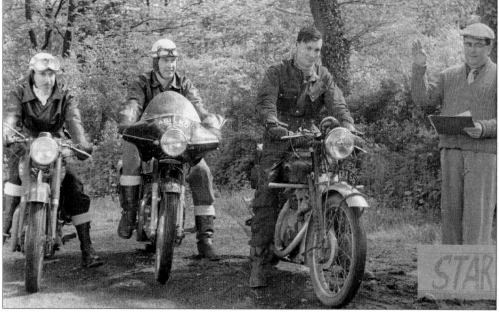

Club official Wilf Emberton starts the first man away in the Basingstoke Motor Cycle Club's road trials in April 1961. These trials were held between Basingstoke and Alton in the thick woodlands of Herriard village. Mr Emberton was the shopkeeper at Punter's in lower Wote Street, one of the many shops that were demolished for the Town Development.

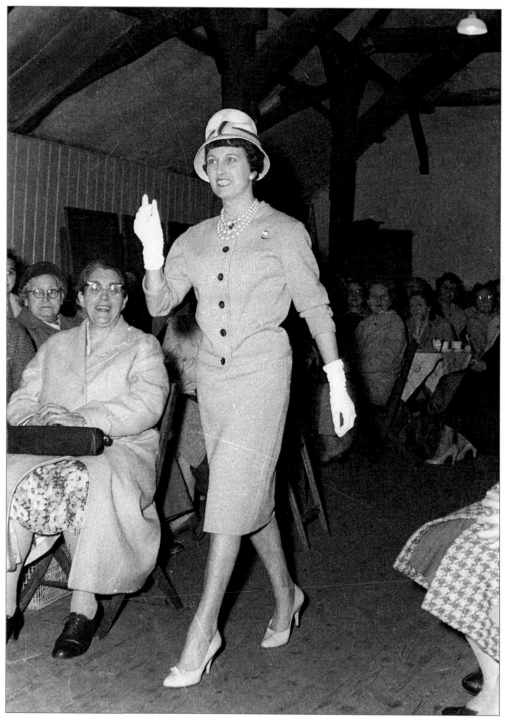

In May 1961 the Basingstoke Townswomen's Guild held a hat modelling session during their coffee morning at Church Cottage, in Church Square. More than fifty hats were shown from the collection of Messrs W. Coombs in Winton Square. Other ladies displayed the hats, including a mother and daughter, Mrs Muriel Wilson and Miss Roberta Wilson. Pictured here is Kay Barber.

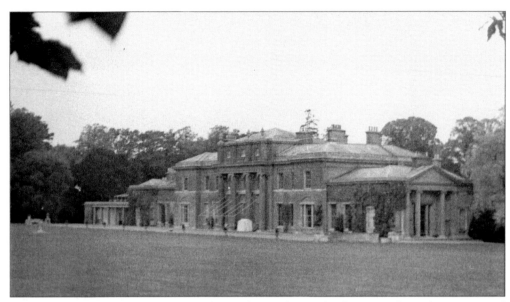

Hackwood Park, with its fine mansion house, lay to the south of Basingstoke and was occupied by the Camrose family. The huge estate of woodland with abundant animal life, including deer, extended to over 2,400 acres, while the house (seen here in 1960), which was built between 1683 and 1687, had extensive reception rooms and accommodation with eight bedrooms on the first floor. Upon the death of Lord and Lady Camrose in recent years the house and estate were sold for £12m to Drumbeat Farming Enterprises in 1998.

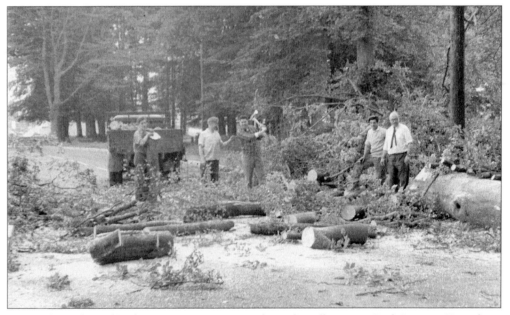

During the early 1960s there was some anxiety about the tall trees in Pack Lane at Kempshott, which were thought to be infected with a disease called Bulgaria Polymortha. Alarmed residents were faced with a crisis as the Hampshire County Council cut some of the roots of the trees when they were laying a path along the road. Eventually several of the trees were cut down in September 1961, and some more were blown down in a storm in the following January. Most of the others were cut down in the following years.

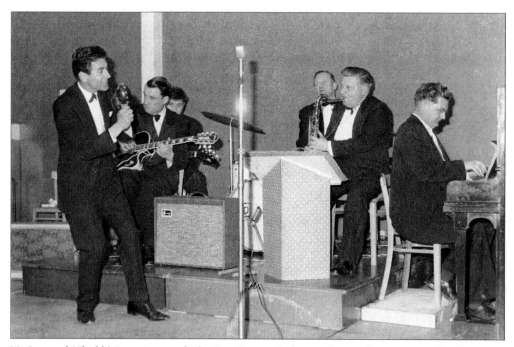

Mr Leonard 'Chubb' Dyer sings with the Ron Young Orchestra during the 1960s at a local hall. Mr Dyer had previously sung with two other bands while living in Bletchley, Buckinghamshire, then on arriving in Basingstoke he also did MC work for the 6.5 and 7.5 Special shows which Jim Miller produced in the town.

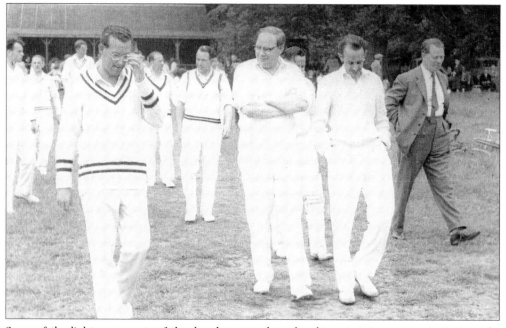

Some of the lighter moments of the decade were when showbiz entertainers came to Basingstoke and district. In 1961 the Roy Marshall team of Hampshire cricketers descended on Oakley, near Basingstoke, to play against the Oakley team at a benefit match. In this picture is Cliff Michelmore (arms folded) of the television programme 'Tonight', while Roy Marshall is on the left.

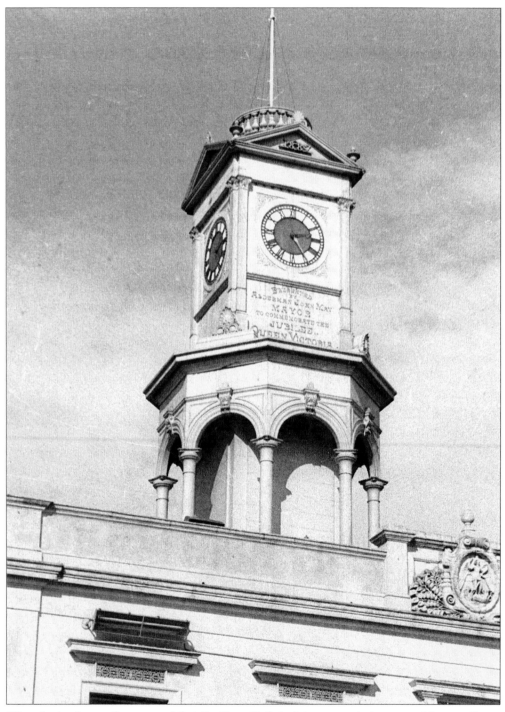

When the local council announced that the Town Hall clock tower was to be removed because it was structurally unsafe, in 1961, the local folk could hardly believe it. This tower, with its four clocks facing each way, had been there since 1887, when it was erected on top of the Town Hall to celebrate Queen Victoria's Golden Jubilee. The local Mayor, John May, paid for the tower to be built; it replaced a smaller tower that was incorporated in the Town Hall when it was constructed in 1832.

The dismantling of the Town Hall clock tower in 1961 was a sad time for local people. The bells were removed to a foundry for melting down into one bell, which was hung in the tower of the C. of E. church of St Paul, Tadley.

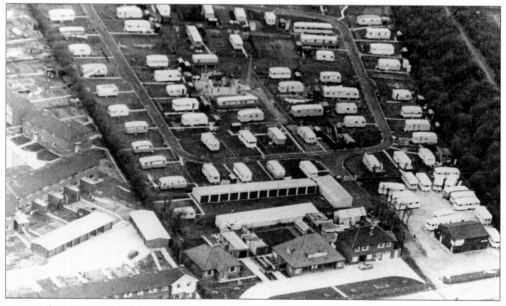

An aerial picture of the Bridge caravan park off Winchester Road, which was situated next to the old Alton Light Railway track. When the Town Development Plan was published in 1962 this caravan site was marked down as being cleared away to allow the construction of the western ring road, which was to follow the route of the old railway line. With the caravans went the Bridge Garage and Café, which were in Winchester Road itself.

Forty years ago Kempshott was just a small village to the west of Basingstoke. Then, with the arrival of the expansion scheme for the town, private land in the village was sold off and used for building houses. By the end of the 1960s Kempshott was an expanse of buildings right to the top of Kempshott Lane, and the smallholdings and garden nurseries which were once the basis of the village were no more. The photograph shows Pack Lane from Kempshott Lane.

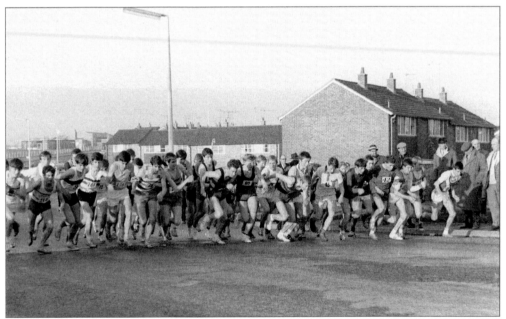

An annual feature in the sporting life of the town in the 1960s was the 'Round the Houses' race around the South Ham estate. In this photograph the runners move off from Western Way on their route through the estate, which had not yet been completed. More houses were to be built in the following years to fill the gap that can be seen in the background.

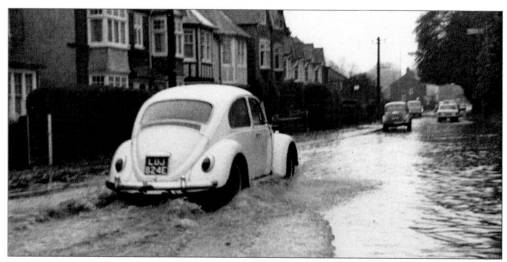

Flooding was always a problem in Basingstoke, especially in the lower parts of the town where the River Loddon flowed from west to east towards Old Basing. The main tributary of the river, in the West Ham fields, used to overflow in heavy rain and create floods in the Brookvale area and in Flaxfield Road further along its route. Even in Winchester Road, near Foulflood Lane, traffic used to have trouble in negotiating its way through the water, as in this picture. Foulflood Lane was renamed Hardy Lane.

During the 1960s the rising generation of youngsters in Basingstoke joined clubs and societies in the town. One such club was the Young Conservatives, who made sure that their programme for each year was interesting enough to hold their members' attention. Here some of the teenagers are taking part in a treasure hunt in the grounds of the club, in Church Street. The club was demolished in 1967 after moving to the Bounty Road site of 'The Mount', a large house once the home of the Twining family (famous for their tea).

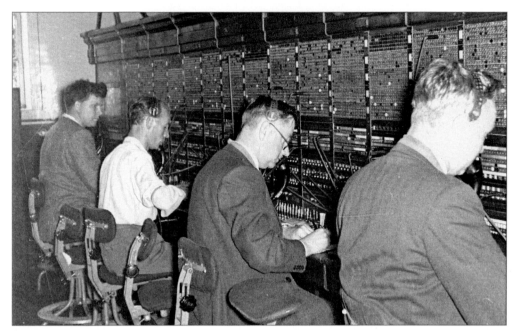

The early '60s saw the end of the old New Street telephone exchange when a new and larger building was erected in Victoria Street. Here four of the many telephonists are in action taking calls from the public. The first switchboard was above a shop in lower Wote Street, then in 1925, when the main post office was built in New Street, a tall square building was erected by the side of it to house the equipment for the new exchange. In 1964 the automatic exchange was opened in Victoria Street.

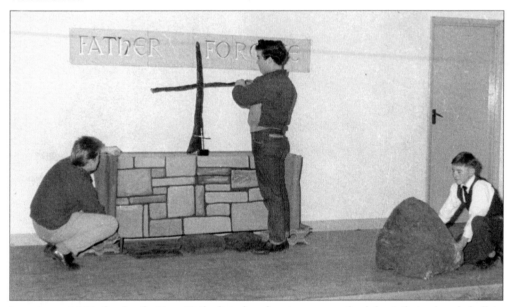

In autumn 1961 the South Ham Methodist church set up a youth club at their church hall in Western Way, which many fourteen and fifteen year olds attended. As Christmas approached the Deaconess, Sister Joan Miller, asked some of the boys if they could help her with the Christmas carol service and suggested a reproduction of the Coventry Cathedral ruins to be laid out on the stage. They were only too pleased to make the props, and here we see three of the boys laying out the stage.

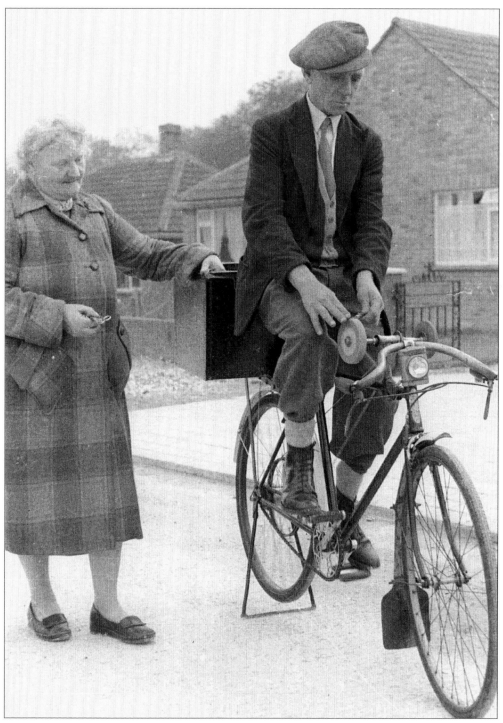

Within a few years of the Berg Estate being built, in 1958, the tradesmen made their appearance on the roads with an assortment of grocers' vans, window cleaners, insurance men and other vendors. One such person was this knife grinder, who had converted his bicycle into a grinding machine, seen here with his wife in Woodroffe Drive.

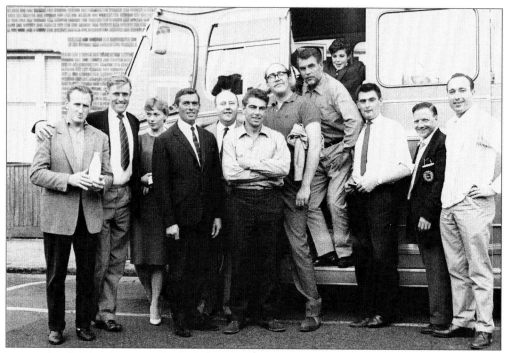

The showbiz teams that came to Basingstoke were a lively crowd and their visits in the early 1960s were looked forward to by the local folk. In this picture, dating from September 1961, a group which attended a football match at the Whiteditch Playing Fields is about to leave to return to London. In the centre (with glasses) is Bernard Bresslaw, the comedian.

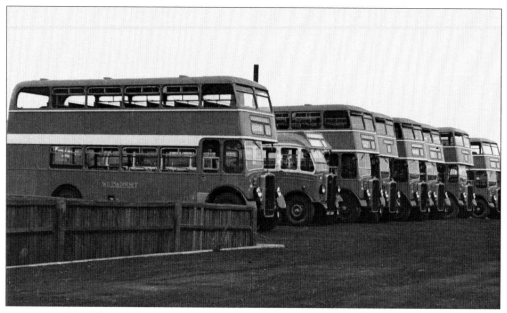

Some of the many buses owned by the Wilts and Dorset company, who had land off lower Wote Street as a depot. The Wilts and Dorset took over the Venture bus service in 1951 and in 1962 the Wote Street site was converted into a bus station, which was demolished in 1999 to make way for a smaller one when the shopping centre was extended the following year.

1962–1963

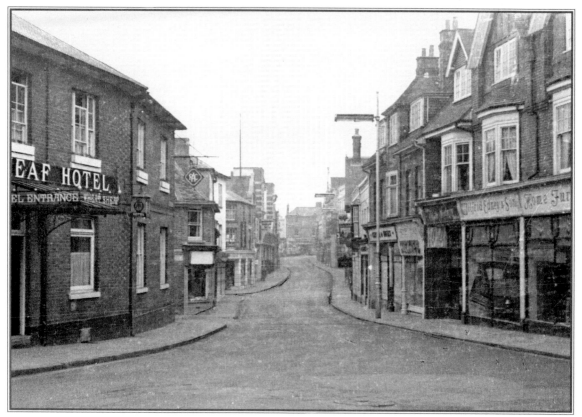

Sundays in the town centre during the early 1960s were not very busy, as very few shops opened on that day. Winchester Street, seen here without any traffic, was a typical example, with not a soul about. By the middle of the decade, with the increase in vehicles passing through the town, this scene was to be just a memory in local folks' minds.

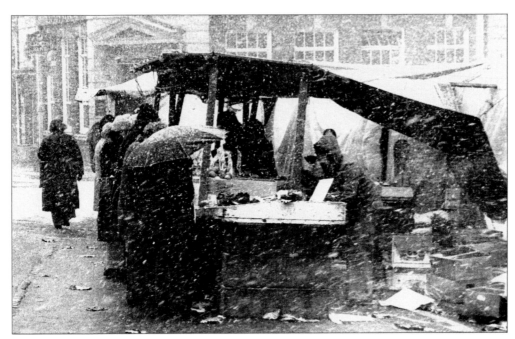

To be a market stallholder you have to be a very hardy soul, for when blizzards blow it is a case of staying put and hoping that customers will turn up, as in this picture taken during the winter of early 1962 in the old Market Place. The market dates back to the twelfth century, when at one time it was held on Sundays.

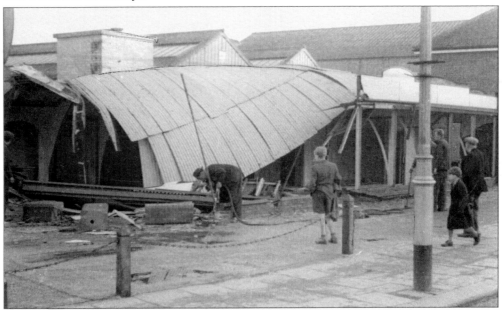

One of Basingstoke's last connections with the Second World War, the British Restaurant in lower Wote Street, was demolished in January 1962. The old restaurant was open between 1942 and 1947 to supply people, on a self-service basis, various meals for 1s each. When the restaurant closed Jackson's garage took over the premises for their offices, showrooms and stores. In 1962 the land was cleared to build new premises for Jackson's, while the firm moved their sales department to their service station on the bypass.

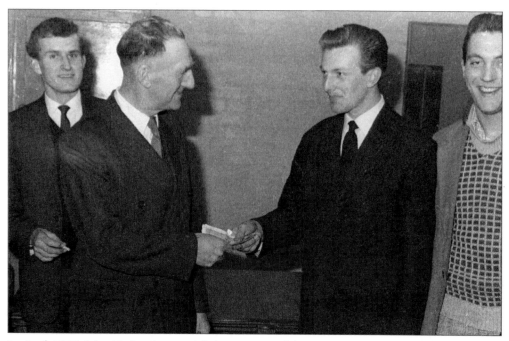

In April 1962 John Finden (centre right), promoter of the Prince Star Entertainments, presented the sum of £40 to George Attrill, secretary of the Parkside Youth Club in Basingstoke, this being the profits of an 'Oh Boy' show held earlier in the year. The money was put into the club's funds for future use.

Before Jackson's Garage was built, on the corner of Wote Street and Reading Road, it was decided to test the ground to see if it was solid enough to take the piles needed to build the five-storey structure. So in February 1962 a pile was driven into the ground and a massive weight of iron ingots 30 ft high and weighing 100 tons was put on top of it. It was finally decided that the ground was suitable to take the weight of the huge building, which remained there until 1999, when it was demolished to make way for a new shopping area.

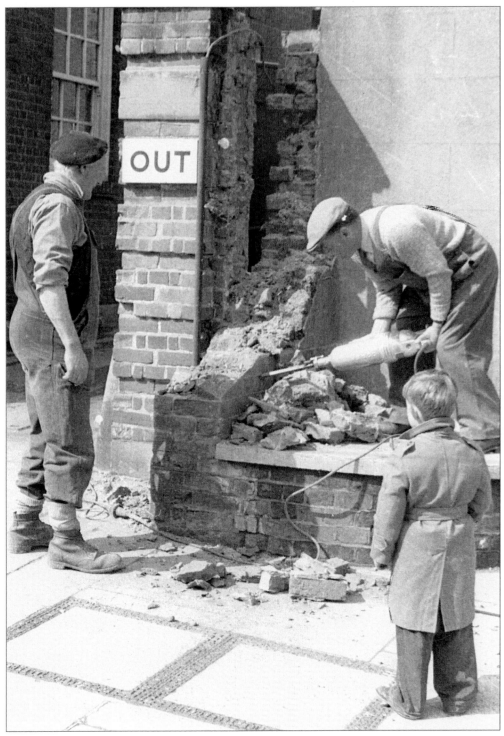

Two workmen began to knock down a wall between the post office and the museum in New Street in April 1962 to find that they had a junior foreman keeping an eye on them. The alterations being made were for the installation of a telephone kiosk.

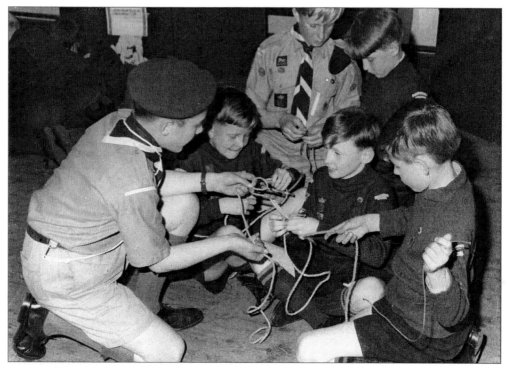

Getting all tied up! This incident was photographed during a display of Wolf Cub activities, and the presentation of the Pack Shield to the 25th Basingstoke Methodist Wolf Cub pack by Mr E.G. Tysoe, the Assistant District Commissioner, at their headquarters behind the Church Street Methodist church in May 1962. The church was demolished in 1967 for the Town Development.

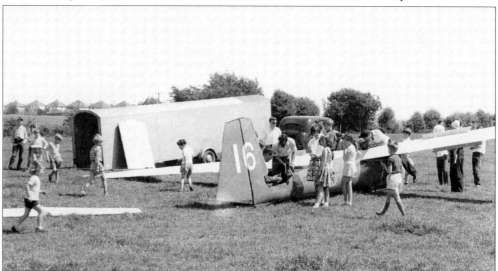

In May 1962 much excitement was caused on the Berg Estate, along the Winchester Road, when a German glider constructed of metal landed on a nearby field. The glider was on a cross country flight from Aston Down to Lasham airfield, when the pilot was forced to land it only a few miles from its destination. It was eventually dismantled and taken back to Aston Down. The glider had been shipped from Germany to Ireland in 1960 and lent to the Royal Air Force at Aston Down in Gloucestershire for a trial flight to Lasham for the National Gliding Championships.

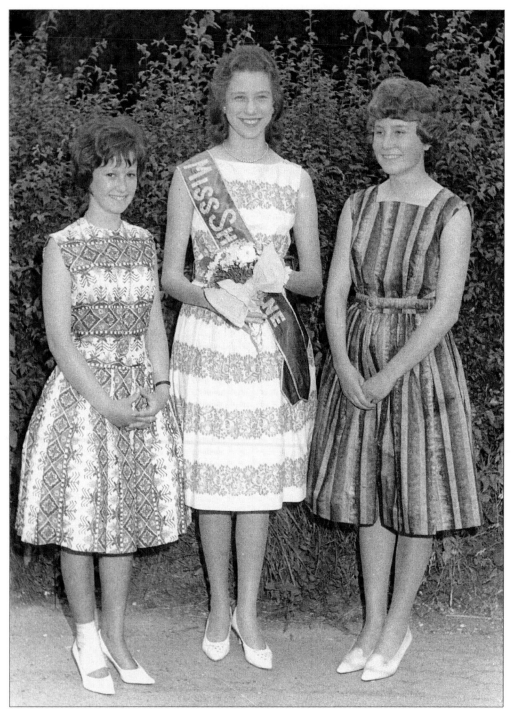

Basingstoke was not the only place to have a carnival: even small villages like Sherborne St John, a few miles north of the town, had their fun in the summer months. In June 1962 fifteen-year-old Julia Rosenwald of Spring Close, Sherborne St John, was selected as the village Carnival Queen, while Patricia Farquharson and Rosemary Lobjoit were chosen as attendants. The selection took place at the village school hall in front of a panel of three judges from Basingstoke.

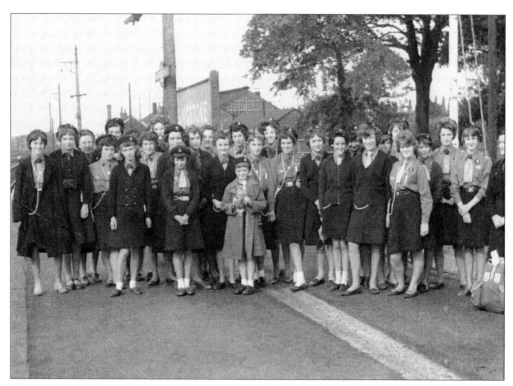

In August 1962 Girl Guides from various contingents in the Basingstoke area set out on a two-week holiday at Adelboden in Switzerland, and when they arrived at the local railway station they found that a party of Basingstoke Air Training Corps cadets were also travelling on the train – but to a different destination. The picture shows the Girl Guides waiting on the platform for the train to arrive.

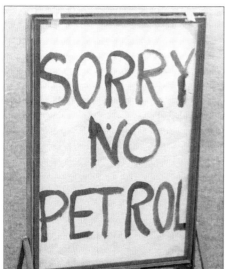
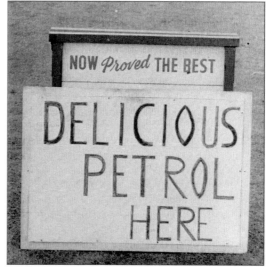

In September 1962 the men who drove the petrol tankers across the country, to deliver to the many garages and filling stations, went on strike. The result was a shortage of petrol for drivers of cars and other vehicles, and many places in Basingstoke had to put up signs saying 'no petrol'. But along the Basingstoke bypass one garage managed to obtain a supply, with the result shown in these photographs.

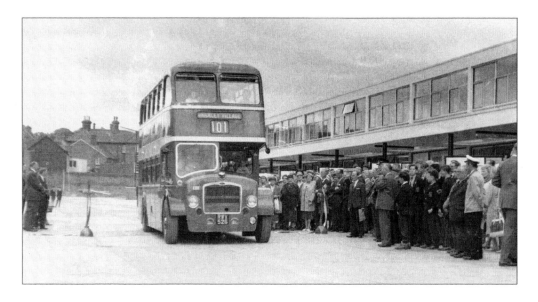

The opening of the new bus station off lower Wote Street in 1962 gave the Wilts and Dorset bus company the opportunity to give Basingstoke people a better service. A restaurant, large waiting room, toilets and information office were included in the complex. The present bus company is Stagecoach.

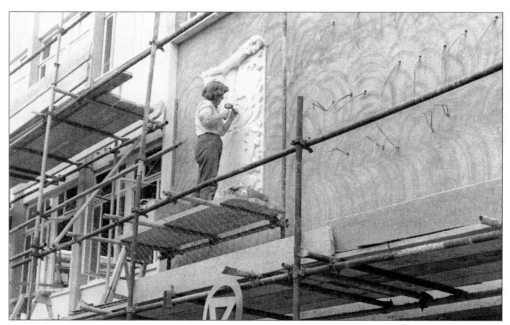

In October 1962 a solitary figure could be seen chipping away at a large stone built into the newly constructed Pearl Assurance House in Victoria Street. That person was Mrs A. Hart of Milford, in Surrey, who was commissioned to carve the firm's coat of arms. As a sculptor Mrs Hart had worked on a regular basis in clay, bronze and wood, and had previously helped her husband who was also a sculptor. In later years Pearl Assurance moved from Victoria Street and the arms were removed.

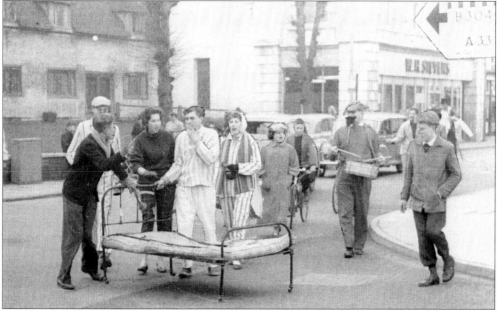

The Technical College students' Rag Week became an annual headache for the local authorities as they never knew what the students would get up to. On one occasion the Rural District Council offices 'lost' their flag-pole in a dawn raid by the students. In this picture a bedstead can be seen being pushed through the town centre for charity.

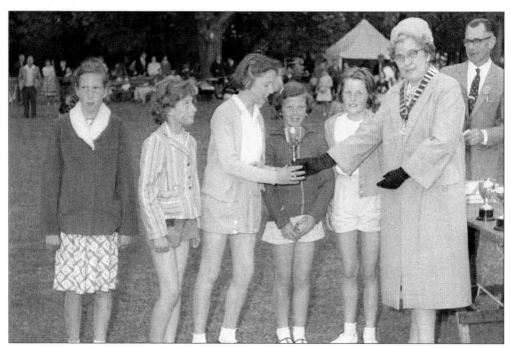

The annual Whitsun sports day was always looked forward to by the local schoolchildren, especially those of an athletic nature, as it gave them the chance to show off their skills. At the end of the day came the presentation of prizes to pupils and schools alike, and here Mrs Peat, the Mayoress of Basingstoke in 1962, is seen handing out cups to some of the winners.

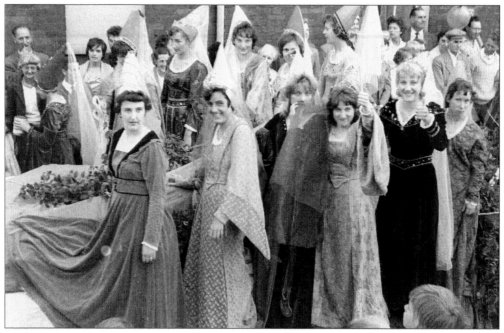

In the early 1960s the carnival procession wound its way through the centre of the town and ended up at the War Memorial Park where prizes were given for the best displays. This picture shows the girls of Eli Lilly's factory, in Kingsclere Road, in their medieval dress as their float passed along London Road.

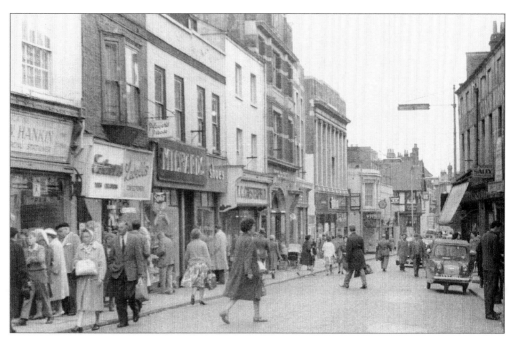

Like London Street, Winchester Street was also part of the original shopping centre before the new one was built in the 1960s. In this photograph, looking towards the New Street and Victoria Street crossroads, the scene is of shoppers bustling from one shop to another. Further down the street is Marks and Spencer's, Burton's, and Milward's, all of which relocated in the new shopping centre.

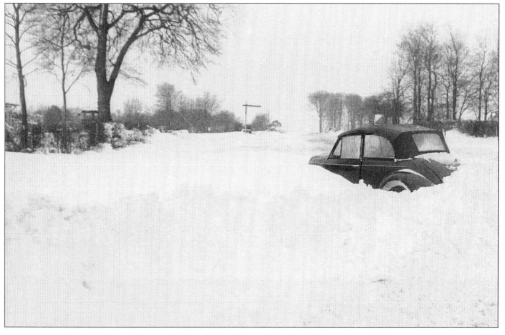

In January 1963 Basingstoke, like other towns in southern England, was hit by heavy snow and icy conditions, which lasted for several weeks. Many roads were blocked by drifting snow, including the main Winchester Road at the top of Kempshott Hill, as illustrated in this picture. The weather even affected the town's market, with just two stalls braving the elements on one particular market day.

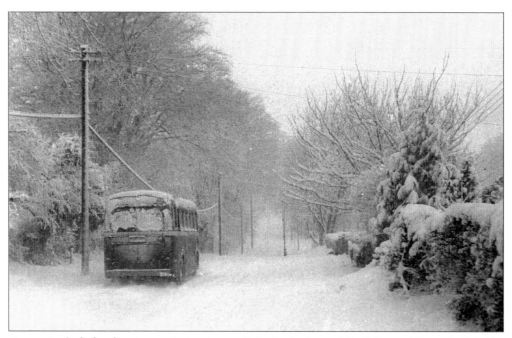

Here a single-decker bus is seen trying to negotiate the inclines of Pack Lane at Kempshott in the winter of January 1963 just after a blizzard. The cold weather lasted for several months, and it was put down on record as the worst winter since 1947.

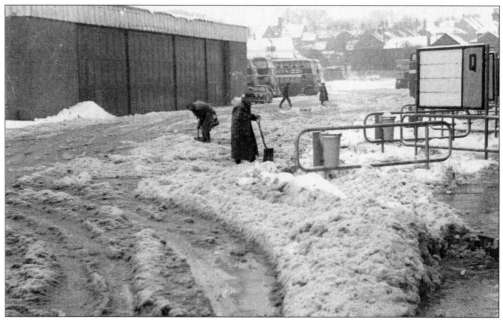

And now for the clear up! After the hard winter of 1962/3 when heavy snow brought chaos to the roads, slush and snow had to be cleared away from the bus station as it seemed to stay forever. These two men spent hours in the cold weather with their shovels trying to make some headway in allowing the buses to get in and out of the station. This picture was taken in mid-January of 1963, when snow ploughs were busy on the main roads and could not be spared for places like the bus station.

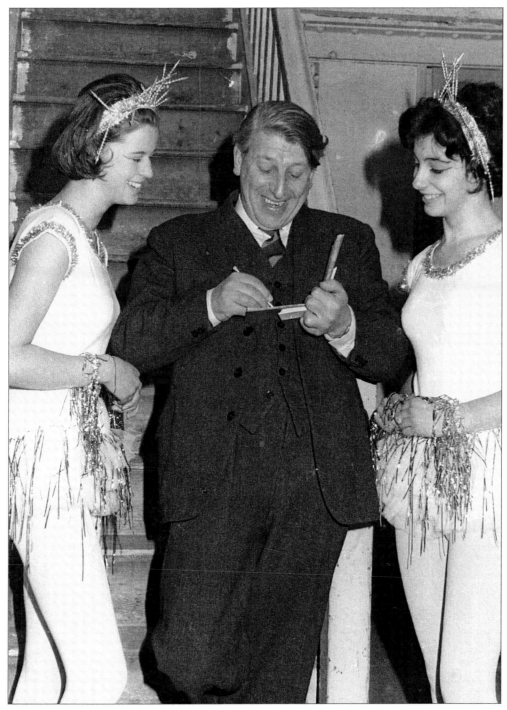

In February 1963 a festival concert was held at the Haymarket Theatre to raise money for the National Children's Home. Among the entertainers was the BBC personality the late Johnny Morris, who is seen in this picture signing his autograph for two pupils of the local Peggy Raynbird School of Dancing, who were among the other artists during the evening's performances. A total amount of £335 was collected for the fund from the concert.

In April 1963 a large crowd gathered at the Engineers Arms public house to see a pile of pennies being pushed over by BBC disc jockey Don Moss (left), Bill McGuffie (pianist) and Ted King (of Radio Luxembourg). The money had been collected over the past year for the National Spastics Society and totalled £25. (The coins were caught in a sack.) The Engineers Arms was situated on the corner of Reading Road and Basing Road, but was demolished in 1967; Eastrop roundabout is now on the site.

In May 1963 the Mayor of Basingstoke, Councillor John Peat, cut the first sod on the site of the new St Peter's Church on the South Ham housing estate. The construction was paid for by diocesan and central church funds, bequests and local money-raising events, which finally brought in the total amount needed of £35,000. In the picture with the Mayor is the Revd R.G. Smith of St Peter's Church, while in the background are other members of the church.

In July 1963 a group of Boy Scouts with their Senior Scouter set off from the Methodist church in Church Street for a ten-day cycle tour of Normandy in France. Pictured here are seven of the eleven lads from the 25th Senior Boys Scouts prior to moving off.

One of the features of Mayor's Day was the number of various local groups that took part, and here the Boys' Brigade band leads the parade down Sarum Hill. The houses in the distance were demolished in November 1967 to allow the new Methodist Trinity church to be built on the site.

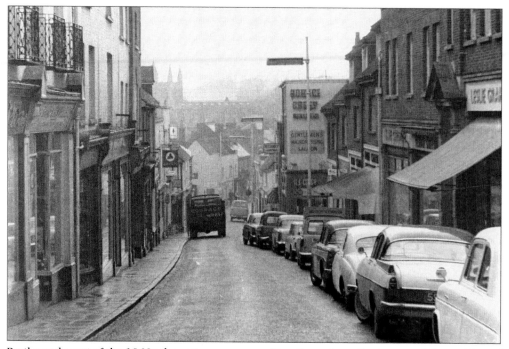

By the early part of the 1960s the motor car was making its mark on the town and the problem of parking was becoming acute. In upper Church Street cars were allowed to park down one side of the road, but this meant that any lorries or vans that had to unload goods for the shops could not stop in the street without blocking it.

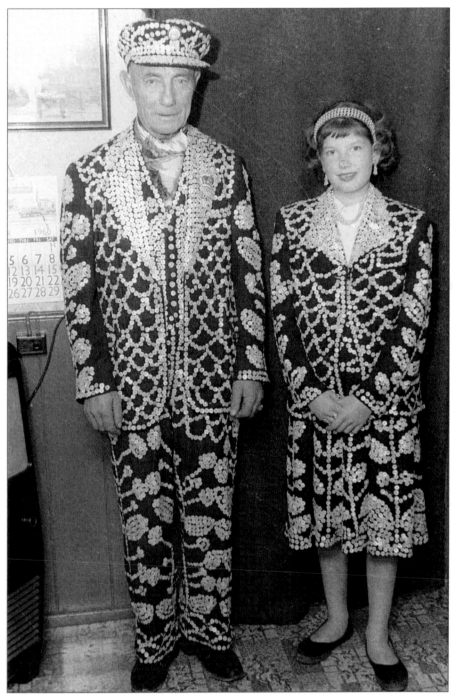

The Basingstoke Pearly King, Patrick Collins of Chapel Street, with the Pearly Princess. Evacuated to Basingstoke from London in 1940, Mr and Mrs Collins settled in the town and began to raise money for various charities as Pearly King and Queen, wearing their outfits with the distinctive masses of buttons. There were 20,000 of them on Mr Collins's coat alone, and 1,800 on his cap. Mrs Collins died in 1959, so her husband hired a young girl to help him, as Pearly Princess. Mr Collins died in March 1978 and was given a grand funeral parade with Pearly Kings and Queens from all over the country.

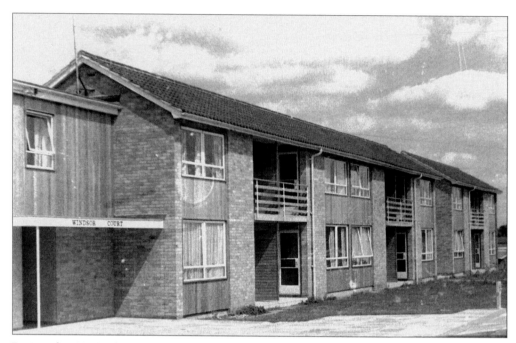

During the 1960s the South Ham housing estate was extended to give more homes to those coming to Basingstoke. Not only were young families catered for but also elderly people, and one such building was Windsor Court, which opened in March 1962. In this photograph the original building is seen, for in 1991 the whole structure was altered and extended, and called the John Eddie Court.

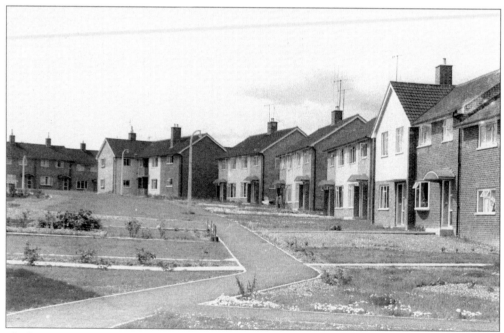

The layout of the houses built on the new South Ham estate was commended by those who lived there, as it gave people more room between their neighbours. An idea of the space can be seen in this early photograph of Woburn Gardens, between Paddock Road and St Michael's Road.

Winchester Road in the 1960s was a quiet highway into Basingstoke, as compared with today's constant stream of traffic. This view of the road shows the entrance into the Smith's Aviation factory on the right, while opposite are the hedges and trees which obscured the Camrose Football Ground. When the ring road was completed this section was widened to a dual carriageway.

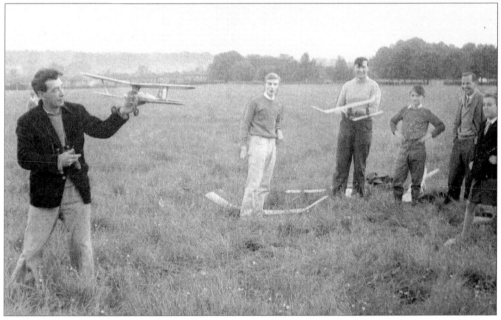

During the 1960s Basingstoke Common was the venue for various activities including the flying of model aircraft. In this picture a group of young men are preparing to fly their aeroplanes. Under the Town Development Scheme the common was transferred to land in Old Basing, and part of the War Memorial Park was moved on to the common. This was because the ring road was built across the lower part of the park.

Left: Miss Gillian Harnett of Heckfield won the title of Dairy Maid of Basingstoke in 1963 when she entered the competition at St Joseph's Hall in Western Way. Seventeen-year-old Gillian was the honorary secretary of the Fleet and District Young Farmers' Association, and she worked as a bank clerk at Hartley Wintney.

Below: In September 1963 the London Street Congregational church celebrated its tercentenary (300th year) and one of the items was a play by Agatha Christie called *Ten Little Niggers*, performed by the Youth Fellowship Drama Group at the nearby May Place Hall.

1964–1965

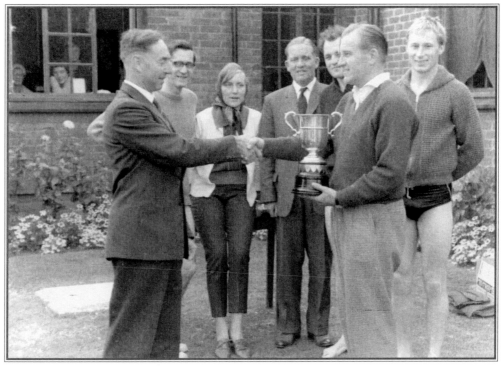

Annual swimming and diving competitions between three of the chief firms in Basingstoke took place during the 1960s. They were Smith's Aviation Works, Blue Peter Retreads and Transport Equipment Ltd, who competed for the KATT Cup. These initials were from the original names of the firms – Kelvin's, Auto Tyre, and Thornycroft. The competitions had been held at the Blue Peter swimming pool since 1938. The photograph shows Mr R. Doswell of Smith's Aviation Works (right) being presented with the KATT Cup by Mr F.W. Andrews. All three firms were to close down in later years.

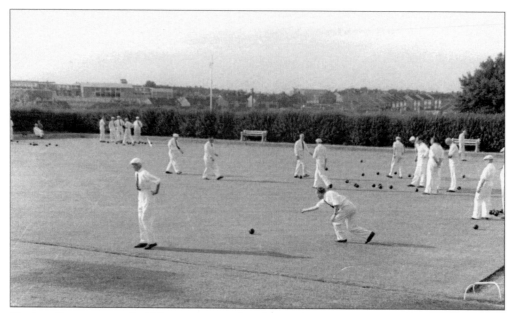

The bowling green at Smith's aviation works along Winchester Road, where regular annual championships took place between local bowling clubs. Smith's, originally Kelvin, Bottomley and Baird when established there in 1937, had football and cricket grounds, with other social activities, but these went into decline in the 1980s and eventually much of the factory was demolished to allow private development. The land was sold and the present Brighton Hill Retail Park was built there in 1996.

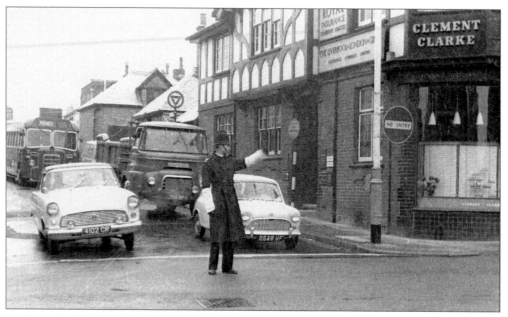

By the 1960s traffic travelling through the town centre was becoming a problem, especially at the various road junctions and crossroads. At the Winchester Street/Victoria Street/New Street crossroads (known as Gifford's Corner from the nearby shop) a policeman had to be on duty during the daytime to prevent accidents taking place. Finally, in April 1976, traffic lights were installed to ease the situation.

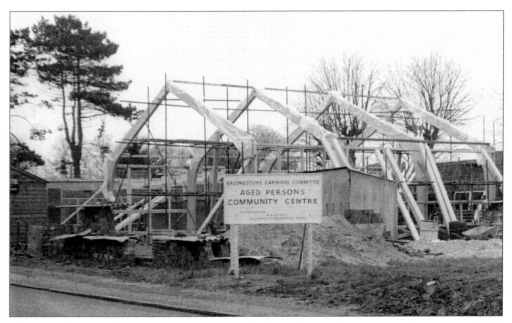

The annual carnivals were a great success in Basingstoke, resulting in enough money to build the promised community centre by 1964. The site chosen was opposite the Fairfields Schools on land once occupied by the school kitchens. The building, named the Carnival Hall, was opened in September 1964 by the Mayor of Basingstoke, Councillor Thomas Baptist.

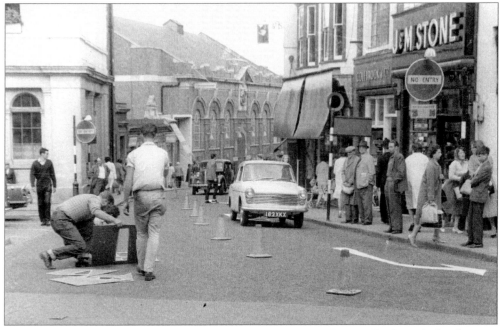

With the increase of population in the town there came a growth in traffic through the shopping centre, so attempts to solve this problem were put into hand by various means, including one-way streets and the re-signing of directions for the motorists. In this case, in the Market Place, workmen are laying down temporary arrows on the road in an experiment to ease the chaos on the busy junction.

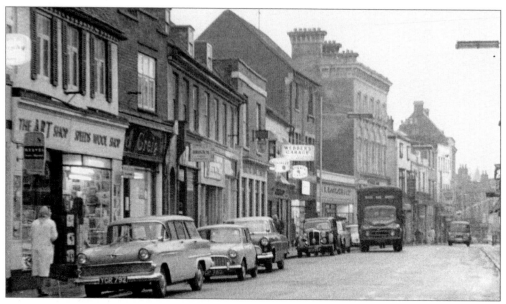

London Street was the High Street of the town in the early 1960s, with Winchester Street, while the Market Place was the hub of the shopping centre. No shop names of that period still exist in the street. In 1976 the street was pedestrianised with the rest of the top of the town some eight years after the new shopping centre opened, in a bid to attract shoppers back.

One of the narrowest roads used by the main stream of traffic is Winchester Street, and even in the early 1960s its limited width was causing problems for extra wide lorries and buses. The narrow path was also a danger for pedestrians, as it is now. The shop on the right of this photograph, which belonged to Mr A. Crate, was demolished in 1971 after closing down in 1965. He established a confectionery and tobacconist business there in 1915.

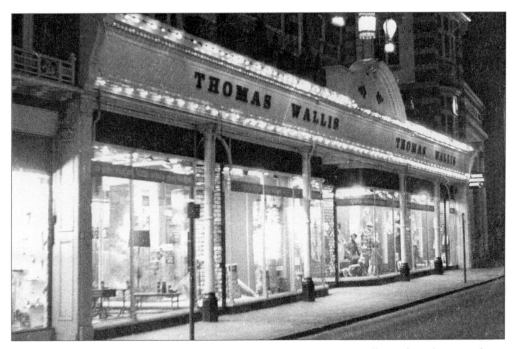

Thomas Wallis's store in Winchester Street, mid-1960s. It was originally Burberry's store after a devastating fire destroyed his old shop in 1905, then Edgar Lanham took it over in 1914. In 1964 Thomas Wallis's acquired the business, then later on Kingsbury's, and finally Maples, who closed down in 1990. The building became a charity shop for the YMCA for some years, then in later years was completely transformed into several units as restaurants and licensed premises.

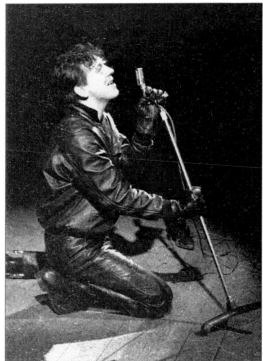

The Haymarket Theatre, in Wote Street, has always been associated with entertainment of all sorts, from old time Music Hall acts to opera and classical music. In the 1960s the stage saw several American stars, such as Gene Vincent, pictured here. Although he had been badly injured in a road accident in 1955 he continued to entertain the crowds who flocked to his shows, the metal brace on his left leg being 'just a slight nuisance'. He died in 1971 aged thirty-six.

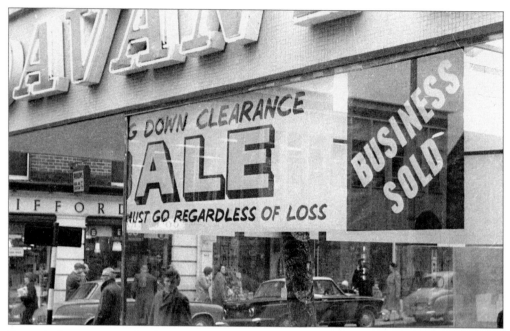

Davant's furniture store decided to have a sale in January 1964 and an assistant put a poster in the window to advertise the clearance. Unfortunately he stuck it on the corner of the window so that part of it showed in Victoria Street and the other part showed in Winchester Street. People in Victoria Street saw only 'down clearance ale must go regardless of loss'. The drinkers of the town were disappointed when they turned the corner!

Forty years ago Basingstoke could boast four fried fish shops which all sold good quality fish and chips. One of these, pictured here, was on the corner of Reading Road and Goddards Lane and was kept by Aubrey Bruton. The other fried fish shops were at 59 Wote Street, run by William Stevens; Red, White and Blue at 10 Cross Street, owned by Mr E. Scott; and the Victoria Fried Fish Shop, just off Victoria Street, which was also kept by Mr W. Stevens.

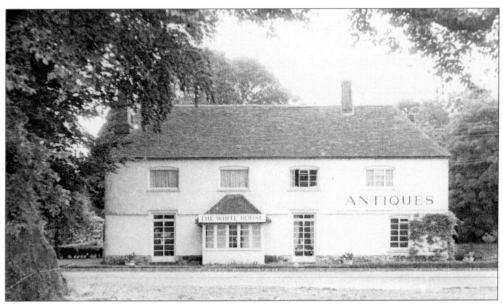

The old White House on the junction of Winchester Road and the Basingstoke bypass was once a farmhouse but by the 1950s it was a restaurant run by H.G. Phipps and R.F. Norris. During the 1960s it became an antique shop, then later on was changed back to a restaurant. In 1988 the present pizza restaurant took over the building. The foreground of this picture is now a traffic roundabout.

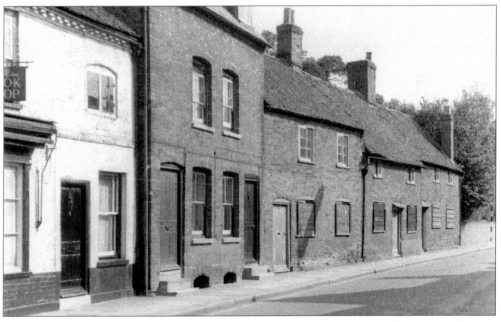

Before the civic offices were constructed in Hackwood Road, in 1975, the road consisted of several businesses and houses, while to the rear of them, on the east side, was the War Memorial Park. After the park was opened to the public in 1921 the old Goldings mansion was used as council offices, but by the 1960s it was realised that the building was too small for all the administrative offices that would be needed for the New Town about to be constructed. Consequently this scene in Hackwood Road was to disappear in later years.

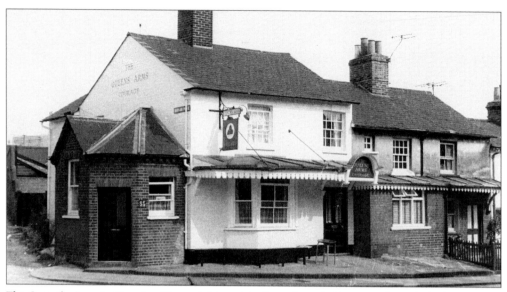

The Queen's Arms in Bunnian Place, right next to the railway bridge, was the only building in the road to be saved when demolition took place. This public house used to serve the staff from the seed merchants of Smith Brothers, opposite, before that building was demolished. Now the Queen's Arms has customers from the offices that were built close by.

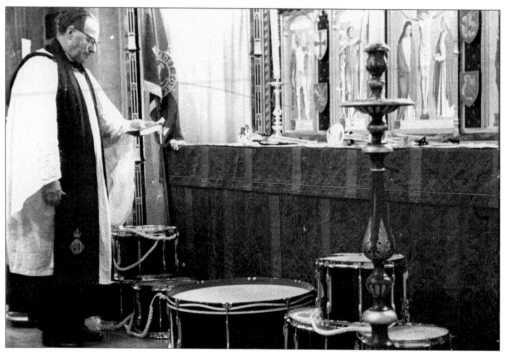

The Revd Norman Woodhall, Vicar of St Michael's Church, blesses the drums of a local band in a special service held at the church. St Michael's had been fully repaired after the bomb damage of 1940, and the 1960s saw the church taking an interest in a more modern way of life. Thus this service of blessing of musical instruments helped people to realise that St Michael's was not so ancient in its ways as the structure of the building was. Dating from the sixteenth century, this parish church had survived a seventeenth-century Civil War gunpowder explosion, and three Second World War bombs in 1940.

As Basingstoke expanded to the north, south and west, there seemed to be little development to the east – but that was to change when the Riverdene estate was built off the London Road during 1963 and 1964. In May 1965 the contractors came under fire for cutting down twenty of the tall trees along the London Road to allow an entrance into the estate. The estate, seen in the background in this picture, was later given a design award for the layout of the houses and their structure.

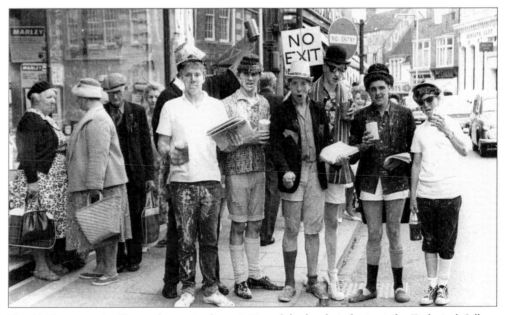

The 1960s saw a significant change in the activities of the local students at the Technical College in Worting Road, with the establishment of an annual Rag Week to raise money for charity. A Rag Queen was chosen and various stunts were planned, although some of them did not have the approval of the College principal. This picture shows six students covered in flour in the old Market Place after a 'battle' to attract attention.

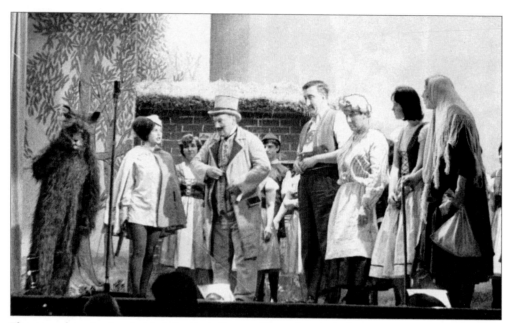

The annual pantomime held at the Park Prewett Hospital main hall was a popular show for both staff and patients in the 1960s. This scene was from *Puss in Boots*, which was acted out mainly by staff from the hospital. The pantomimes were always held in January. A fire destroyed the hall in April 1981. The hospital buildings were closed down in March 1997 to make way for a housing estate. Previous to that the new Basingstoke Hospital was erected from 1969 on the land

Another of the highlights of the early 1960s was the annual Firework Fiesta, which took place in the War Memorial Park annexe in early November. With the fireworks came a giant bonfire, and in this photograph, taken in 1964, the Mayor of Basingstoke, Councillor Tom Baptist, and his wife, are watching the bonfire being lit.

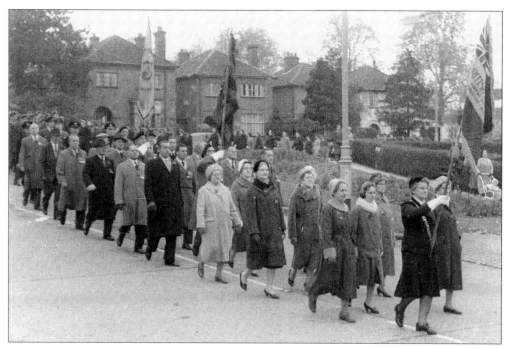

Members of the Basingstoke group of the British Legion marching down Eastrop Lane after an Armistice Day parade in the early 1960s. Other local groups were also represented, such as the St John's Ambulance, Boy Scouts and Girl Guides groups. In the 1960s the service of remembrance was held at the war memorial in the park, but in later years the service was held at St Michael's Church.

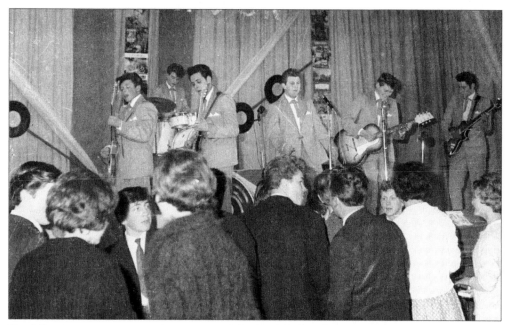

The Mimets pop group in action at one of the local halls. This was the scene during the rock and roll years in Basingstoke when local people such as Johnny Prince (real name John Finden), 'Chubb' Dyer and Jim Miller brought this type of music to the youngsters in north Hampshire.

In the mid-1960s Basing House near Basingstoke was the scene of considerable research and excavation to find out more about the old castle, which was the setting for a siege between the Royalists and the Cavaliers in the seventeenth century. An old well was probed by members of the Reading branch of the British Aqua Club but little of any value was found. It was hoped that the depths of the well would reveal the treasure that was hidden during the two-year conflict.

Getting the stalls to the Market Place for the twice weekly market was always a struggle, especially for those who had to push their stalls up Wote Street from where they were kept, as seen here. Some of the stalls were stored in various sheds and old stable buildings which existed behind the shops and other buildings, which were later demolished as part of the Town Development Scheme.

In 1960s the Kempshott villagers had to contend with a small hall for their gatherings, where only small numbers of people could meet. At wedding receptions it was a case of praying for dry weather so that the guests could stand outside to avoid overcrowding in the hall. In 1968 a new and larger hall was built close by because of the population increase in the area.

In the early 1960s a familiar sight in the War Memorial Park was this young lady walking her St Bernard across the grass. The park offered a vast expanse for the public, from the Hackwood Road side across to Basingstoke Common, and on to the Black Dam ponds. The Town Development Scheme brought this country walk to an end by transferring the common to Old Basing.

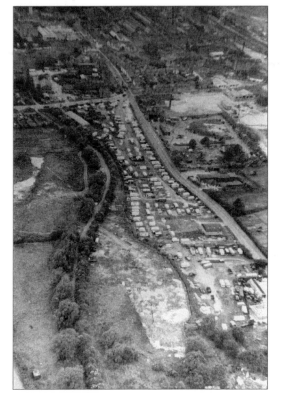

The caravan site along Basing Road belonged to Mr Alfred Cole and was the subject of compulsory purchase incidents. 'Alfie' Cole protested at the small amount of compensation for the land, and made several protests: for example, he travelled to Downing Street in the hope of seeing the Prime Minister, and in 1968 he dumped several mounds of earth on to the main streets in the centre of Basingstoke, causing traffic chaos. He eventually got the amount he wanted.

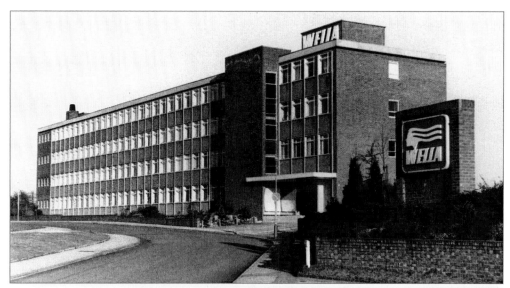

One of the many firms that came to Basingstoke under the Town Development Scheme was Wella Ltd, the manufacturer of hair products, who moved to the town in 1962. At first the building, built on a hill off Winchester Road, on the Bilton industrial estate, had only two floors but later on it was made into a four-storey structure. The firm has enjoyed a prosperous business over the past forty-eight years.

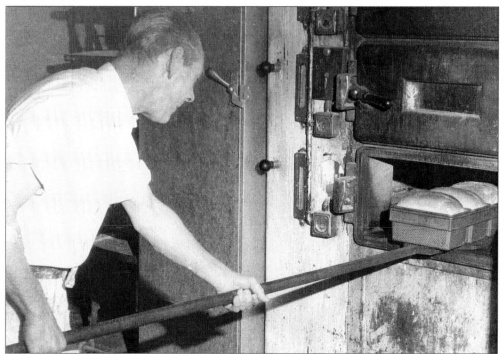

Before the 1960s there were eight bakeries, but the closure of several in the 1950s, such as Thornton's bakery in Flaxfield Road, led to the local folk buying their daily loaf from only a few. One such shop was Giles's bakery in lower Wote Street, although this building was to close and be demolished in 1966. Pictured is Mr Elton removing the last loaves from the ovens before the shop was closed down. He had been with the firm for thirteen years, and had baked some 500 loaves each night.

The trackway of the old Alton Light Railway near the Basingstoke bypass before the Brighton Hill housing estate was built. Some of the trees that lined the track can still be seen by the side of Hatchwarren Lane. The railway was built in 1900 between Basingstoke and Alton but was closed in 1914 to allow its track to be used in France during the First World War. Ten years later it was re-opened, but again closed to both passengers and goods in 1936 because of a lack of business.

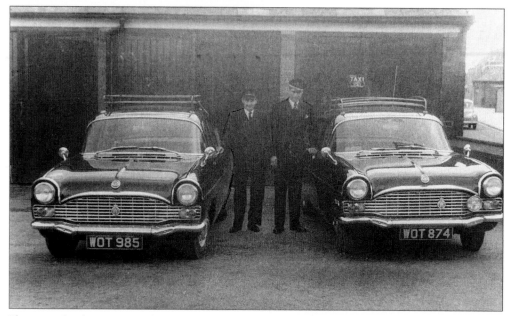

The main local taxi service began its life back in 1946 when Mr A. Stowell started his business with one car, which he parked on land in Worting Road. In 1955 he acquired the Dykes Hire Service in New Road and formed a taxi fleet with radio controlled equipment in all the vehicles, and ran it as a twenty-four hour service, helped by his wife and father. In August 1965 he closed down the taxi service to concentrate on providing cars for funerals. The photograph shows two of the taxis and their drivers in the car park of the now demolished Barge Inn, in lower Wote Street.

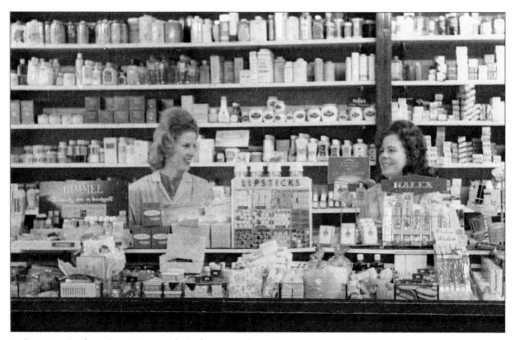

Before Boot's the Chemist moved to the new shopping centre in 1968 it had a prime position in London Street. On one side of the interior was the drug counter, with its pharmacy, and a small photographic section, as well as a farms and gardens counter. On the other side, pictured here, was the toilet department and surgical section.

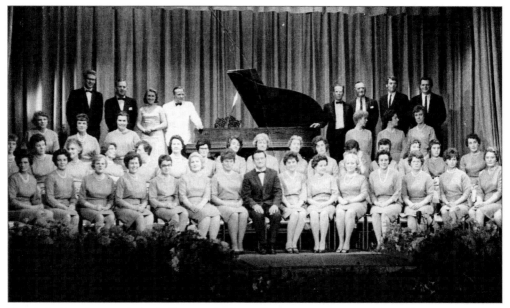

The Oakridge Singers Ladies' Choir with their Choirmaster Mr Kenneth Williams on stage at the Haymarket Theatre. Formed in 1965, the forty lady members, comprising housewives and professional women, met once a week to share the pleasure of singing ballads and light musical songs. The choir went on to become associated with singing for charity to raise funds for various local needs. Kenneth Williams was a newcomer to Basingstoke and had sung with Cornish choirs before moving to the area.

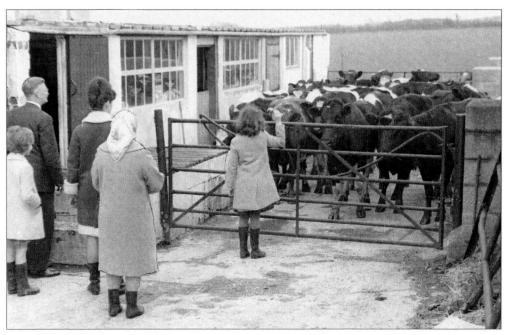

Hatchwarren Farm was often an attraction for visitors and schools, as it gave children an idea of how the average farm operates. Over the years, after the announcement of the Town Development Scheme in 1961, the farmland was taken over by the authorities piece by piece for housing. Even now land is being built upon for private housing, and the view of fields that once could be seen from the top of Kempshott Hill is now a sea of roofs.

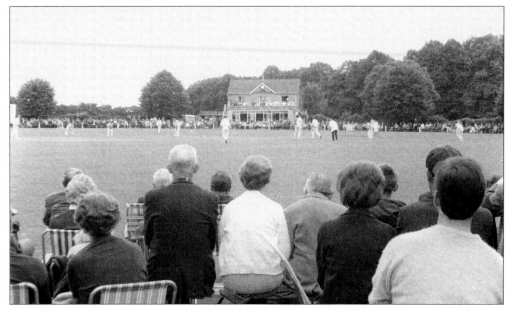

Every May the local folk would assemble at May's Bounty to watch the Basingstoke and North Hants Cricket Club play against various teams from around the country. Usually in June the Hampshire cricket team would come to play against another county team, and this would attract crowds from all over southern England. The pavilion, seen here in the distance, had been rebuilt as a larger building by the end of the decade.

The villages around Basingstoke were blessed with plenty of social activities which gave young and old enjoyment outside working hours. For those who did not work a full day, such as housewives, there were daytime pursuits such as the Women's Institutes, and at Cliddesden, just south of Basingstoke, the ladies were photographed having tea after a performance by an invited guest.

Sandwiched between two shops in Wote Street was a flight of steps that led up to the Liberal Club, and it was here that regular whist drives were held. When the area was compulsorily purchased in 1966 a new Wote Street Club was built in the nearby car park between Wote Street and New Road.

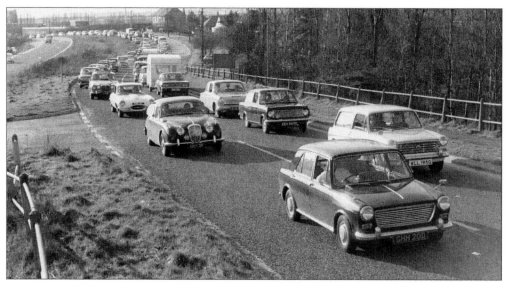

Until the M3 motorway was built at the end of the 1960s the main stream of traffic heading between London and the south coast had to flow along the Basingstoke bypass, and in the summer holidaymakers had to contend with long lines of cars which sometimes stretched from Winchester to Staines. Now the old bypass, built in 1931, is severed at the Black Dam ponds and is swallowed up by the present ring road system.

One of the regular carnival events was a donkey race, and here are the two winners charging past on the Camrose football ground in Winchester Road. In the background can be seen the stands where the football fans used to watch the matches, until a new grandstand was built in 1971; this also housed changing rooms and other facilities.

The annual Whitsun attractions in the War Memorial Park brought crowds flocking from all over the town, and one year they watched this man trying to drive a motorised go-cart across the arena with a small black sack over his head. It caused some amusement, and consternation, especially when he nearly ran into the audience during his stunt.

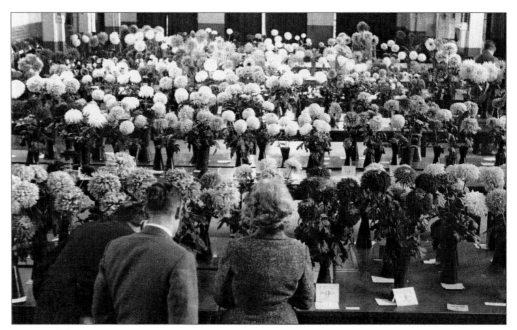

A fine display of flowers at the Basingstoke and District Chrysanthemum and Dahlia Society's annual show at the Thornycroft Canteen, mid-1960s. Each entrant's blooms were judged on their merit, and prizes were given for various presentations, such as for artistic display. The Thornycroft Canteen, built in 1918 for workers from the factory opposite, was demolished in 1997.

Some of the members of the Towana Dancing School after an evening of prize-giving at the Kelvin's Social Club Hall along the Winchester Road. The school, started by Tony and Diana Robbins in 1963, was one of several similar schools in the town which were established to allow young people to develop their skills in that field, while other youths were rocking and rolling the nights away.

CHAPTER FOUR
1966–1967

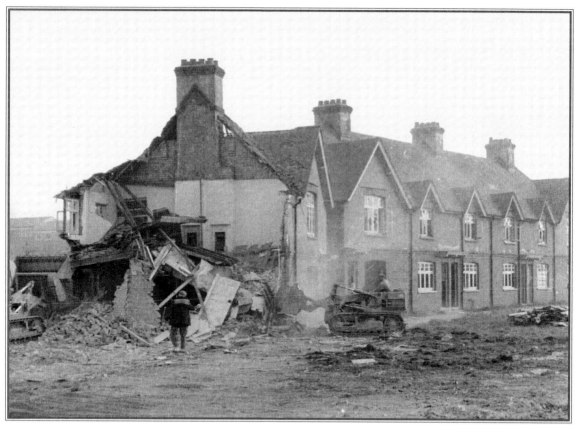

At a time when brand-new council houses were being built in Basingstoke a whole row of old ones was being demolished in Cranbourne Lane, in 1966. They were the oldest council houses in the town, having been built in 1914. All twenty-eight of them were constructed at a total cost of £7,200, which included the acquisition of the land. The site was later used for building new homes and shops, while the road was re-named Wessex Close.

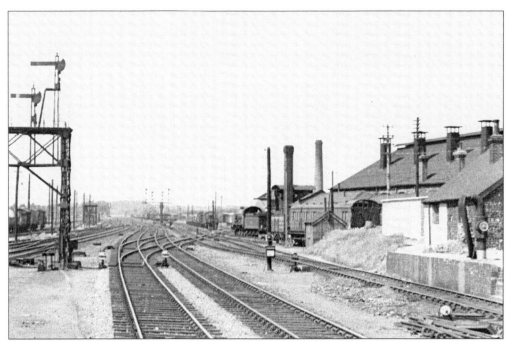

Before the electrification of the railway line through Basingstoke and the use of signal lights the west side of the railway station seemed to have been in a time warp, with its semaphore signalling. Soon after this picture was taken electric track was laid and the old signals were replaced with illuminated signals. The sheds on the right were also demolished.

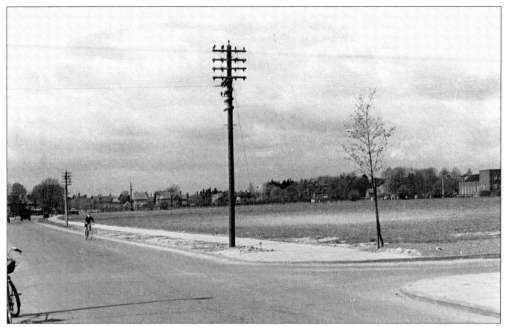

By 1950 the Southview housing estate has been built north of the town and some people wondered why one road, Queen Mary Avenue, had been built so wide. By the 1960s, when the traffic had increased along the road, they were to find out why. The field in the photograph, which belonged to Queen Mary's School, was to be sold later for housing.

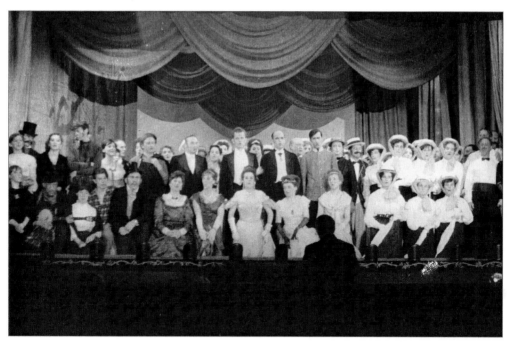

One of the most popular shows of the decade at the Haymarket Theatre was the Edwardian Music Hall in May 1966. Audiences loved it and applauded the grand finale each night with great gusto.

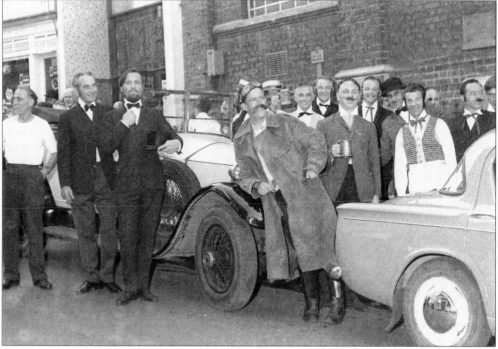

Some of the people involved in the Edwardian Music Hall at the Haymarket Theatre pose for a photograph outside the theatre in Wote Street. An Edwardian motor car was hired to drive round the town to advertise the show; it can just be seen here.

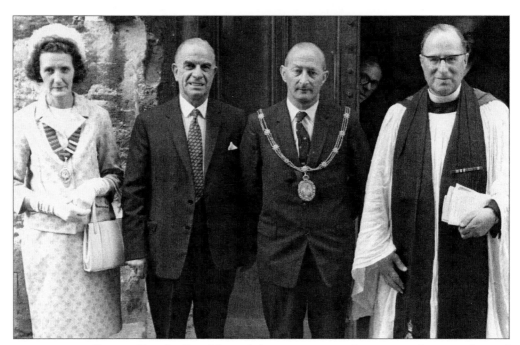

In 1966 Councillor Harold Redstall and his wife became Mayor and Mayoress of Basingstoke, and during his mayoral reign he became a popular figure. He associated himself with as many aspects of the town's social, commercial, and political life as possible, and was on friendly terms with most of the people he met. Here he is leaving St Michael's Church with his wife, Mr Tom Cooksey (Road Safety Officer), and the Revd Woodhall (Vicar of St Michael's Church).

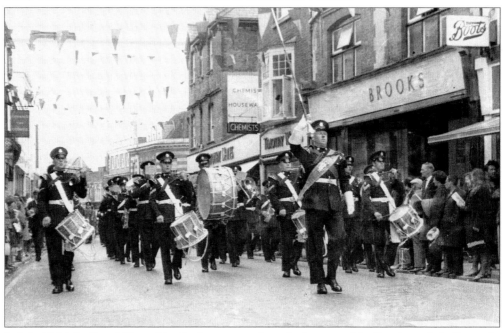

In July 1966 the Royal Hampshire Regiment was given the honour of the Freedom of the Borough, and marched through the centre of the town for the presentation from the Mayor, Councillor Harold Redstall. The picture shows the parade entering London Street from the Market Place.

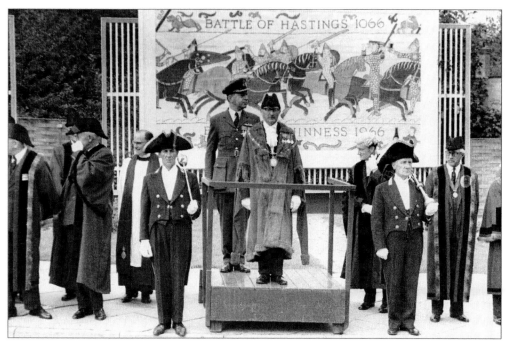

The Mayor, Councillor Harold Redstall, stands on the corner of Cross Street and Church Street awaiting a parade in 1966, while in the background a poster shows another Harold being defeated at the Battle of Hastings in 1066 – exactly 900 years before.

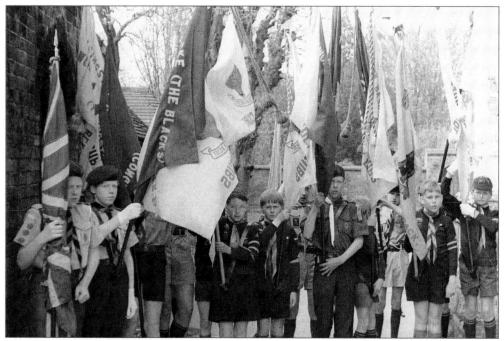

Local Cubs and Scouts gather with their banners and flags in Church Street after marching through the town in a St George's Day parade, in 1966. These parades attracted local folk from all over the town and the streets would be crowded with onlookers, as various groups celebrated the patron saint of England's special day every April.

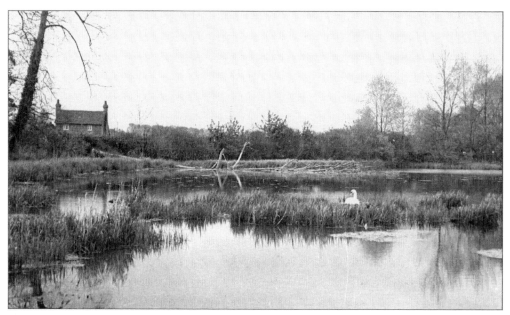

The Black Dam pond before it was altered in the late 1960s. This area was a popular place for local people as it held an abundance of fauna and flora. There were four large ponds here, Lower Fish Pond, Upper Fish Pond, Mill Head and Black Dam. In the background is Hayward's Cottage on the bypass. In October 1966 the ponds were polluted by styrene, when a lorry containing the liquid overturned nearby. It was several years before the ponds returned to normal.

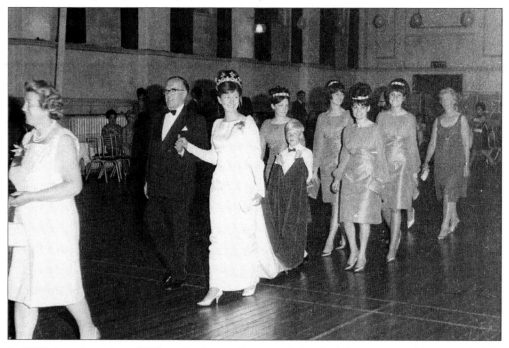

In 1966 Jean Cumming of Hillary Road won the annual Carnival Queen competition, and in July fulfilled all the engagements that were planned during Carnival Week. One of the events was attending the Carnival Ball at Park Prewett Hospital, and here Miss Cumming is seen being led into the huge hall with Mr W. Gittoes, the Carnival secretary, and her retinue.

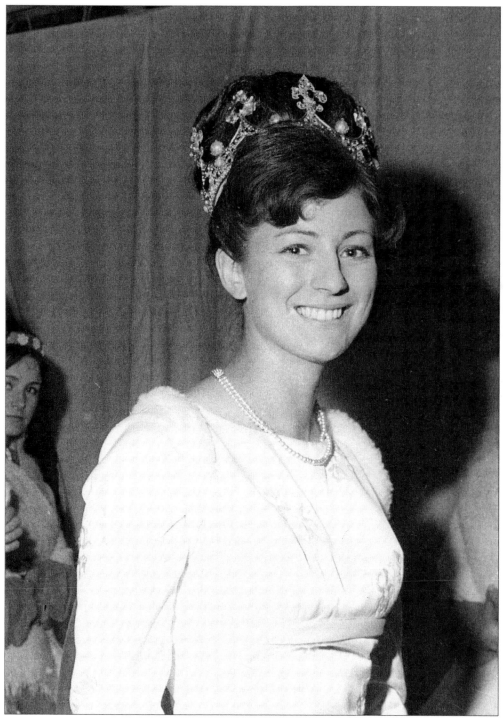

Jean Cumming. Throughout the 1960s and '70s the carnivals were very popular and were equal to those of Andover and Fleet, where similar events were held. The carnival queens and retinue would be invited to each others' processions which gave the occasions more interest to the crowds that attended.

One business that was greatly missed when it closed in 1966 was the cycle repair shop belonging to Mr Charles Everett. It was in Potters Lane at the Church Street end of the road. Originally opened at 35 Church Street in 1910 it later moved to Potters Lane, where the upper floor was used as a photographic studio. Mr Everett not only repaired bicycles but sold them as well, with all the necessary equipment.

One of the many grocers in Basingstoke in the early 1960s, the Winchester Street shop of Mr H.C. Ody, had been established in the town since 1884. The new shopping centre opened in the lower part of the town in 1966, and this shop closed in September of that year. Later the Halifax Building Society took over the premises and transformed its interior. Before the late nineteenth century the building was used as a bank, while before that the site held the Maidenhead Inn.

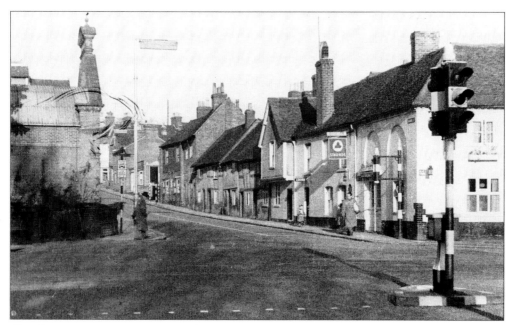

Chapel Street, in the lower part of the town, was one of the oldest parts of Basingstoke, and its demolition in 1967 brought condemnation from many local folk who knew that much of the road had been listed as a preservation area. It was assumed that the fires at the council offices in 1956 and 1957 had destroyed the documents relating to their protection, and there was no confirmation of the preservation orders.

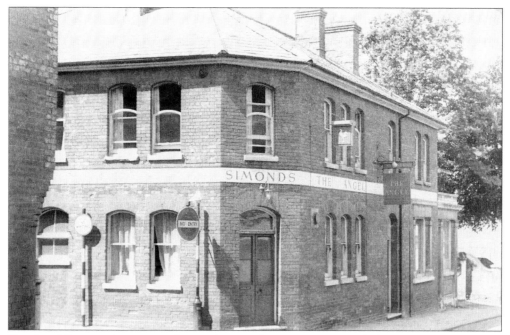

The Angel Inn, on the corner of Wote Street and Potters Lane, just before its closure, and later demolition, in 1966. This was one of the many public houses that had to be pulled down to make way for the new shopping centre. The Angel Inn dated from 1870 and was built on the site of the Cross Keys tavern, which in turn was erected on the site of an old pottery, hence Potters Lane.

One of the greatest tragedies of the Town Development Scheme was the demolition of Church Street Methodist church in January 1967; it had been restored only fifteen years before, after Hitler's bombs severely damaged it in 1940. This grand church was built in 1905 to replace another that was moved, stone by stone, to Cliddesden in 1904.

In 1966 St Andrew's Methodist Church in Western Way received an organ from the Cliddesden church after it had been fitted with an electric motor and a new console. This organ dated back to 1879, when it was placed in the Methodist church in lower Church Street.

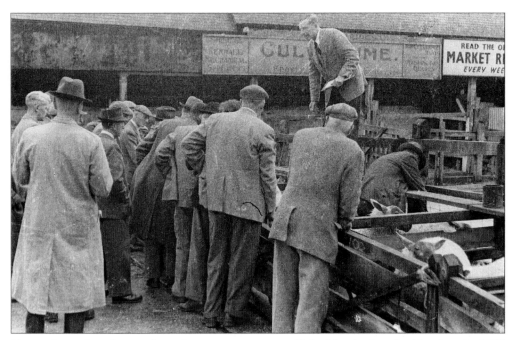

The cattle market, close to the railway station, was established by the Raynbird brothers in 1873 and over the following years was the venue for the sale of various farm animals including cows, sheep, pigs and hens. On 4 May 1966 the market was closed to allow the site to be cleared of buildings for the construction of Alencon Link offices. In this photograph an outside auction of sheep is taking place close to the main arena. The market was held every Wednesday.

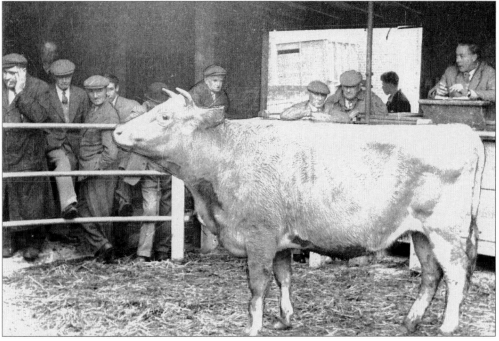

A scene at the weekly cattle market, near the railway station, during the auction of animals that took place there. Farmers came from all over the south of England to attend the market.

A few of the many ex-scholars of St John's C. of E. School in Church Street who assembled there in early 1966 to say an emotional farewell to the building. The schoolmaster, teachers and pupils of past years gathered in the hall for speeches from other dignitaries about the school's history, and to hear the many stories associated with the sixty-five-year-old establishment. These five ex-pupils later visited their old classroom to sit and reflect on their past years at the school, which was demolished within a year of its closure.

An annual event in the War Memorial Park was the Whitsun Fête and Sports Day, at which schools from the Basingstoke area took part in various activities. Held between 1948 and 1967, it was organised by the Basingstoke and District Trades Council to provide Bank Holiday entertainment for local children. As well as sports there were various stalls selling goods and other items.

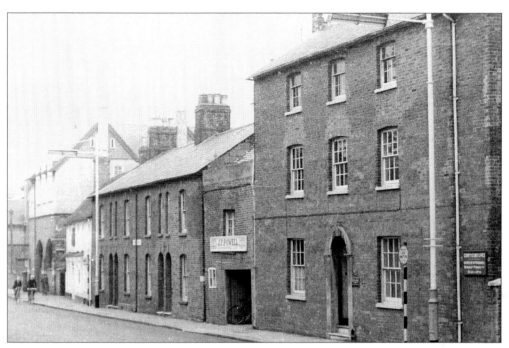

Lower Church Street was to suffer the fate of many of the roads in the town centre. This photograph shows the section between the County Court offices (right) and St John's Church of England School (in the distance).

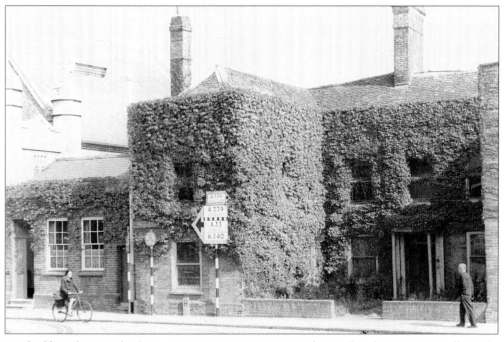

One building that caught the eye was Queen Anne House in lower Church Street, especially in the summer when its ivy was in full growth. This turned a beautiful colour in the autumn and made this part of Basingstoke quite picturesque. Queen Anne House was demolished in 1967, but the portico was saved by the Museum Service.

One of the many eating places that were closed down and demolished to make way for the new shopping centre was the Chinese restaurant in Potters Lane. The demise of this building in 1966 meant the end of an historic place, for it was originally a corn store, then the meeting place for the Wesleyan Methodists in the nineteenth century. By 1876 it had been converted into the British Workman public house, then later into a coffee tavern under the same name. The title continued when it became a restaurant, and even when the Chinese restaurant took over locals still dubbed it 'The Workman'.

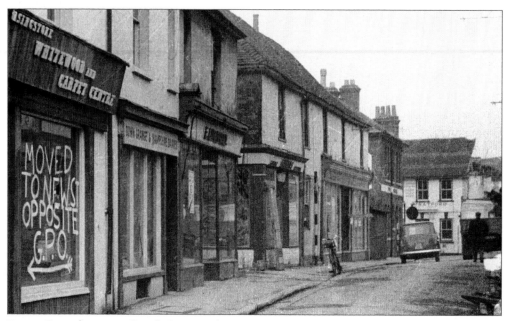

Potters Lane, between Church Street and Wote Street, saw the closure of its shops from 1964 onward, until November 1966 when the demolition vehicles started their massive task of clearing that part of the town centre, moving relentlessly northward. The land was eventually levelled off up to the railway station by the end of 1967. By then work had begun on constructing the new shopping centre on the site shown here, which was to be called Potters Walk.

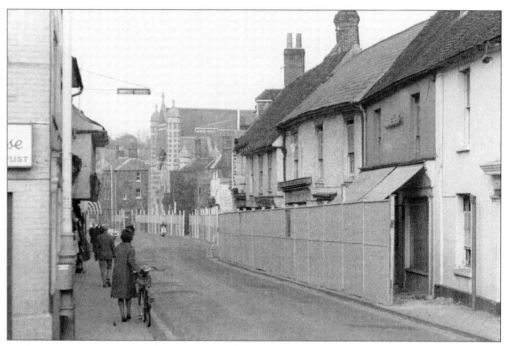

As the shops closed in Church Street, so the barriers went up in readiness for the buildings to be pulled down. This row of shops included a hairdresser, a watchmaker, a tailor and a paint shop. Further down the road can be seen the prominent Methodist church, which was built in 1905.

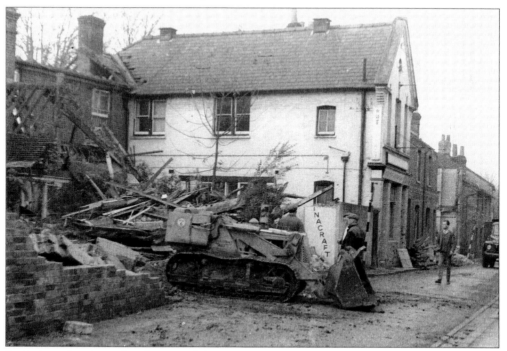

On 1 November 1966 demolition work began to clear the old town centre of its buildings, with the first road being Potters Lane. The wall being knocked down in this picture had been rebuilt only a few years before, after it was blown down in a storm.

One of the many public houses to be pulled down under the Development Scheme was the Rose and Crown on the corner of Potters Lane and Church Street. Built in 1669, it was one of the more popular inns of the town, even though the main door was on the brink of a busy road. Those staggering out at night had to be careful they were not run down by passing cars!

Mr Derek Boshier and his wife say farewell to the Railway Arms on the night of its closure, 31 August 1966. It was demolished in the following January because of the construction of the new shopping centre. This public house dated from about 1840, shortly after the railway arrived in Basingstoke, although the building was thought to date from an earlier period.

On 31 August 1966 the Travellers Rest public house in lower Wote Street closed down to allow the new shopping centre's construction. Evelyn and Arthur Grimble, left in this picture, had served their last pints for the brewery, and their customers turned up on the night to bid them farewell.

The Barge Inn was also lined up as a victim of the demolition because of its position in lower Wote Street, and on 29 September 1966 it closed. Mr John Hopkins, the proprietor, and many of his customers gathered to say their last goodbyes. The public house dated back to the late eighteenth century, having connections with the Basingstoke Canal, which had its wharf opposite the building until the 1930s.

St John's Church of England School in lower Church Street, before its demolition in October 1967. The building dated from 1896 when it was opened as a Sunday School; then in 1901 it was enlarged as St John's National School for 130 boys and girls and 230 infants. Enlarged again in 1905, it became a County Council school in 1940. It closed on 21 July 1967 to allow the Town Development Scheme to be implemented.

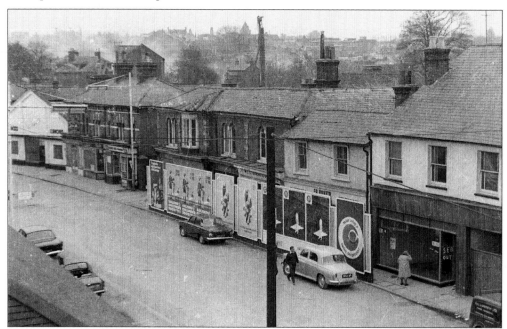

Lower Wote Street's shops and other premises were slowly emptied in 1966 and 1967, then hoardings were erected in readiness for demolition. The land behind had already been acquired so that the pile-drivers could dig their holes for the concrete foundations of the new shopping centre. This view was taken from the old Waldorf Cinema building, which was demolished in 1999.

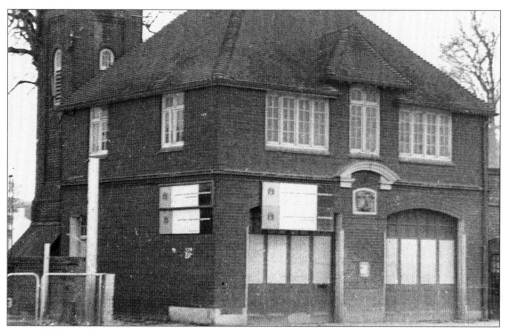

Some of the buildings that had to be demolished had provided a great service to the town, and one of them was the fire station in Brook Street. Built in 1913, it was closed in August 1966 and demolished in October 1967. A new fire station had meanwhile been constructed at West Ham roundabout to provide a fire service for Basingstoke and district.

This attractive residence in Goat Lane, between Wote Street and Eastrop Lane, fronted the funeral directors and monumental masons business of Alexander and Dry (established in 1923), who were forced to move because of the Town Development Scheme. They were relocated to a site not far away in New Road. The recent new shopping area scheme threatened to demolish their present building, but they have now been informed that this will not be necessary. The house and offices in this picture were demolished in November 1966.

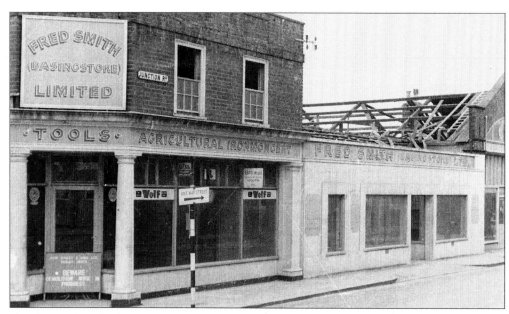

The shop and works of Fred Smith's agricultural business in Junction Road during the early stages of its demolition in 1967. The firm's other buildings stood in Station Hill, and all were compulsorily purchased under the Town Development Scheme, and closed down in July 1966. The business was established in 1880; in July 1967 it moved to North Waltham, south of Basingstoke.

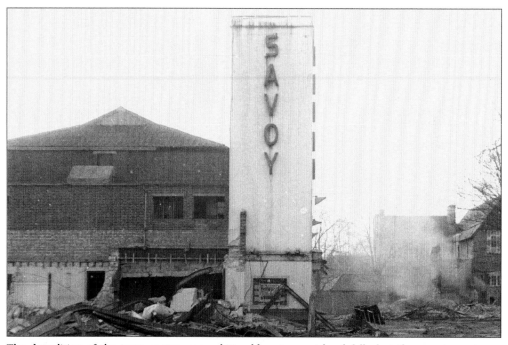

The demolition of the town centre was a bitter blow to most local folk, but the worst upset was when places where they used to enjoy themselves were pulled down. One such building was the Savoy Cinema, at the bottom of Wote Street, which dated back to 1939, although a cinema, the Electric, had stood on the site from 1910 onwards. The Savoy closed in August 1966 and was demolished the following year.

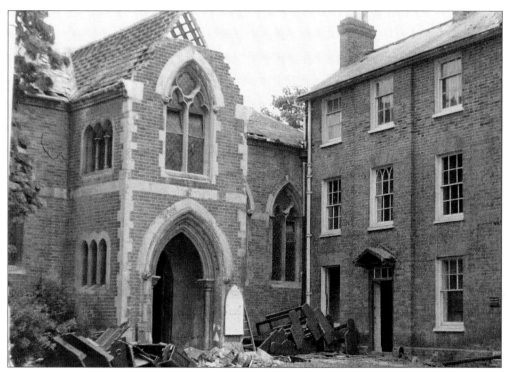

When the Immanuel church and manse were demolished in Wote Street most of the cellar was filled up with rubble and then cemented over. Years later, after Fads shop had been built on the site, the area in front of the shop began to sink, so further cement had to be used to level it off. The church dated from 1775, was rebuilt in 1802, and enlarged and restored in 1874. It was attended by members of the Lady Huntingdon's Connexion (a non-conformist religious sect).

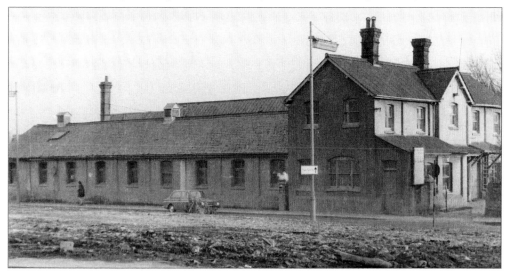

With the demolition of the Engineer's Arms public house the full extent of the Basing Road laundry could be seen. The Basingstoke Steam Laundry and Baths was opened in 1885. By the beginning of 1960 it was being run by A. and D.E. Horne, and was advertised as launderers and dry cleaners. After being compulsorily purchased for the Town Development Scheme it closed down in November 1966 and was demolished in February 1967.

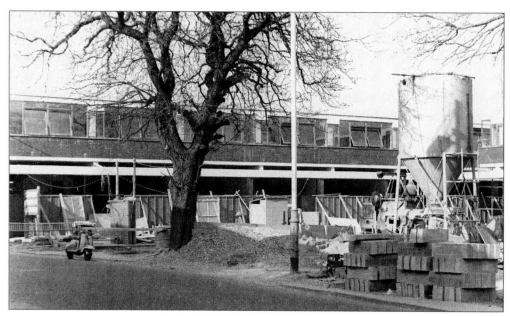

Construction of the new Market Square on land which was once part of the Basingstoke Canal wharf. Two of the original trees were retained in the square, which once stood on the south side of the wharf. The Market Square was opened to the public by September 1966 with market stalls selling goods similar to the market by the Town Hall at the top of the town. Thirty-three years later the Square was to be demolished to make way for a new shopping area.

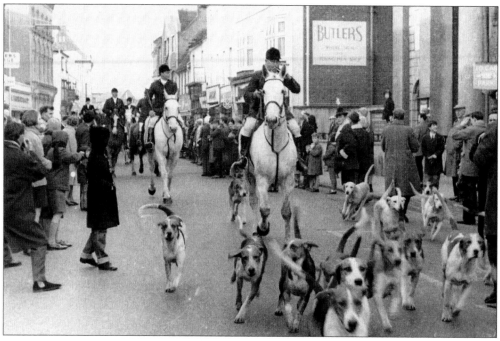

The Vyne Hunt's meeting in the Market Place every Boxing Day was always an attraction to the public, so after it amalgamated with the Craven Hunt in 1967, and moved away from the town, the day after Christmas Day was never the same! The photograph shows the hounds and huntsmen moving off to Old Basing along London Street.

1968–1969

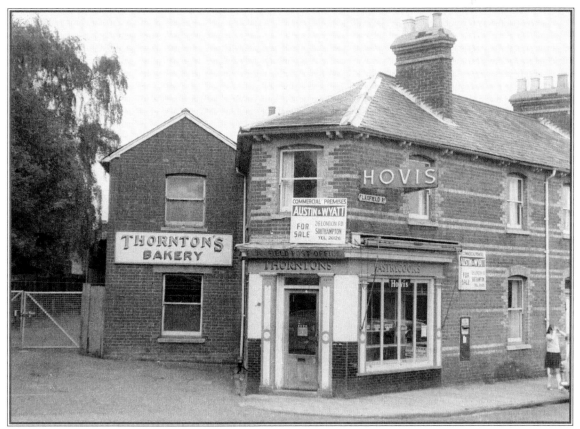

Thornton's Bakery in Flaxfield Road was established in 1886 by Henry Thornton. When he died in 1950 he left behind a chain of bakery shops and cafés across northern Hampshire. In August 1957 the bakery at the rear of the Flaxfield site was gutted by fire. Ten years later the shop and bakery closed, and in March 1968 the building was demolished to make way for a garage.

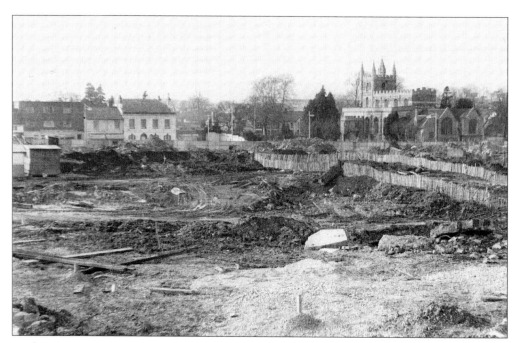

As clearance work continued between Church Street and Wote Street in January 1967 for the new shopping centre, the remains of bodies were found in the grounds of the Society of Friends' Meeting House in Wote Street. Work was held up for weeks while the bodies were removed and buried elsewhere. This area was fenced off.

Just off Reading Road were the gardens belonging to the Society of Friends, the Quakers: part was used as a burial ground. When the land was cleared in 1968 some bodies were uncovered, and work had to stop for a while until reburial could be carried out.

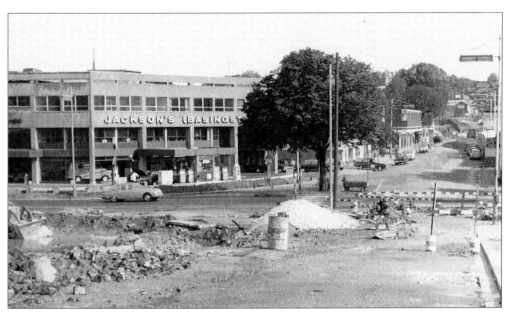

As the Station Hill buildings were demolished during 1967, so a vista of lower Wote Street was opened up, showing Jackson's Garage and the east side of Wote Street, with the Waldorf Cinema, in the background. Almost central in the picture is a hornbeam tree, known as the 'Reformers' Tree' because of meetings held underneath it at the turn of the twentieth century. This tree and the horse trough under its boughs were removed during redevelopment.

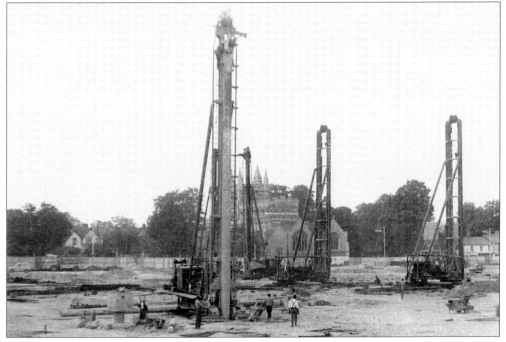

After the demolition of the old shopping centre came the pile drivers, which thumped their way into the ground day after day to construct the foundations of the new shopping centre. To those living near the town centre, such as the residents of Church Square, it was a nightmare, but eventually the holes were dug and the actual construction of the concrete complex was begun.

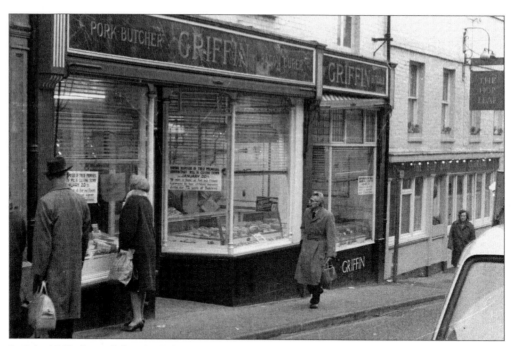

In July 1968 the pork butcher's business of Griffin Brothers at 17 Church Street closed down after seventy-two years. During that time they had built up a reputation for good quality meat, and the making of the 'Basingstoke Pork Sausage'. Their speciality was cooked meat, and their pies brought in a steady stream of customers.

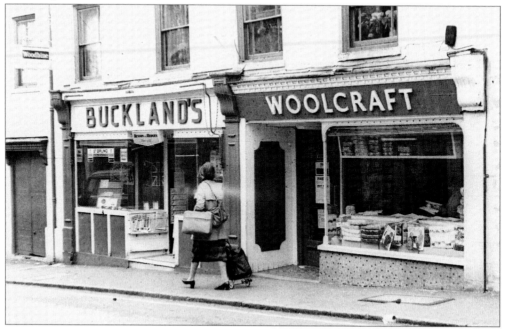

Two shops in upper Wote Street during the 1960s were Buckland's and Woolcraft. The former originated in William Buckland's stationery business, which was further up Wote Street facing the Market Place and dated back to late Victorian years. When W.H. Smith's took over the premises in 1934 Buckland's moved lower down the road. The shop closed in September 1978.

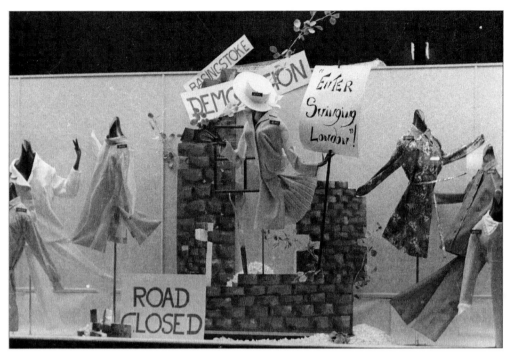

This unusual window display at Thomas Wallis's store in Winchester Street illustrated the mood while all the demolition was taking place in the lower part of the town. With the emphasis on the destruction of the buildings, the road closures and the arrival of newcomers from the London area, this window gave the local people something to smile about in 1967.

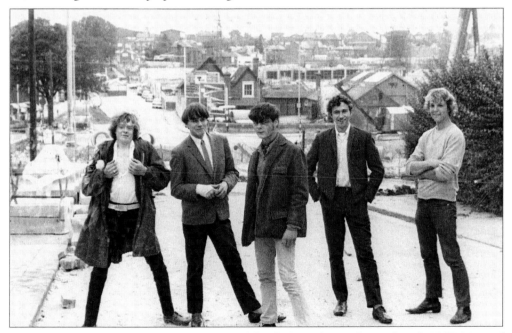

Five youths pose for a picture in Station Hill while all about them is being altered, 1967. Many of the youngsters in Basingstoke were aware that the Town Development Scheme meant a much better place was being planned for their future, and by the end of the 1960s that vision came to fruition.

May Street, a long straight road with nearly two hundred homes in it, together with a few shops and other buildings, was destined to be demolished under the Town Development Scheme as it stood in the way of the planned link road between the shopping centre and Ringway West. So in early 1968 the gradual evacuation of the residents took place, most of them being placed in new homes on council estates, and in August of that year the whole street was cleared, except for one building on the corner of Lower Brook Street which comprised 191 and 193 May Street, and is still there.

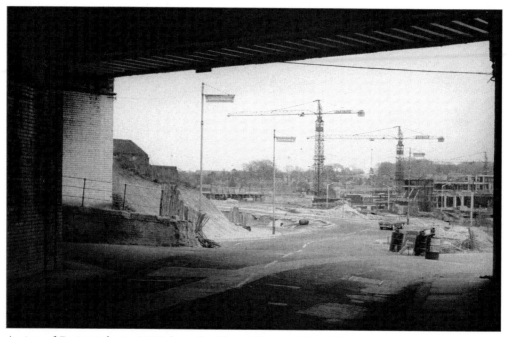

A view of Basingstoke in 1968 from the Chapel Street bridges. Visitors to the town, oblivious to the mass development taking place in Basingstoke, were often shocked when they entered the area by both road and rail, as they saw all the demolition and construction work going on. Motorists arriving from the Newbury route were aghast as they came through the bridge into the town centre, as the railway station hid the view from them as they travelled down the hill.

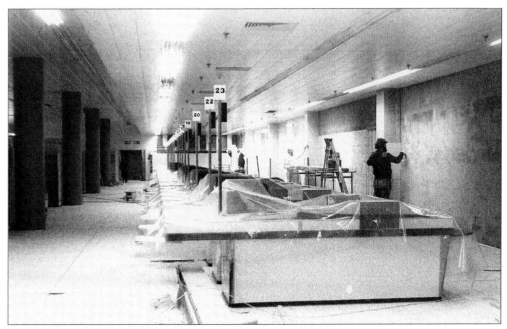

As the first phase of the new shopping centre neared completion so the shopfitters moved in to assemble the counters and decorate the walls. Here, at Sainsbury's store in Chelsea House, the fittings are ready for the tills, all twenty-three of them.

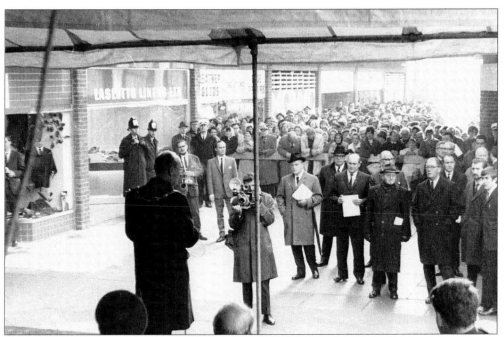

The Mayor of Basingstoke, Councillor J. Balding, officially opened the first phase of the shopping centre on 12 November 1968. He cut a tape with a pair of scissors presented to him by Mr B. East of the Town and City Properties, the company responsible for carrying out the development. The Mayor spoke of the years of history that had been lost in the mass demolition of the old town, but the town gained a newer and more modern centre in the process.

Some of the hundreds of people who waited for the opening of the first phase of the new shopping centre in November 1968. The £10 million shopping centre was to provide sixty shops in this section by the time Christmas had arrived that year; then in 1969 work was extended to the lower part of the town.

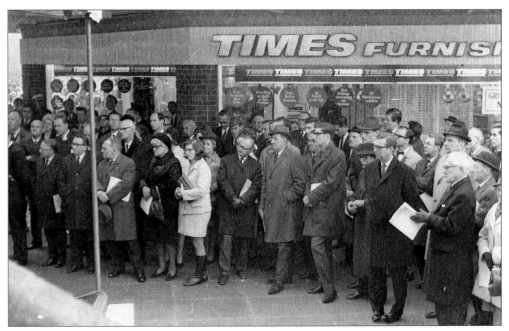

Some of the many dignitaries, including local councillors, who attended the official opening of the new shopping centre on 12 November 1968. Members of the press and television were also present, resulting in much publicity for this turning point in the town's history. The first phase of the shopping centre was to be followed by subsequent development in the following years, as construction continued towards the railway.

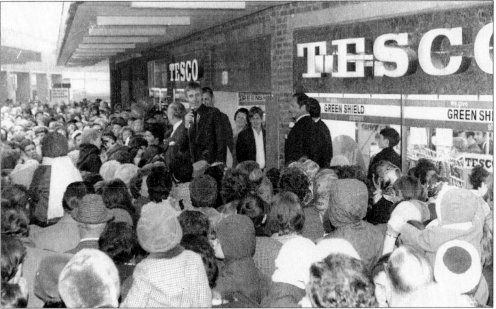

After the shopping centre was opened on 12 November 1966 so came the official opening of some of the shops there. One such store was Tesco's and here the famous DJ Simon Dee is seen announcing to the audience that the store is ready for them. Some years later Tesco moved out of the town to Chineham Shopping Centre. In more recent years other Tesco shops have been opened on various estates while a new shop was established in the shopping centre.

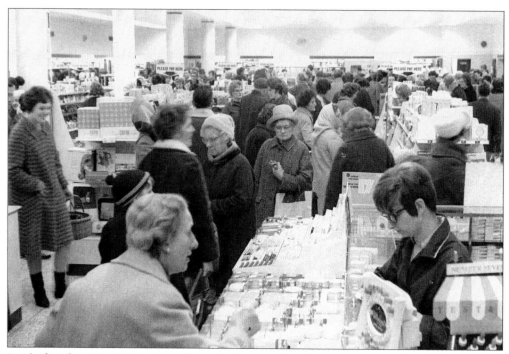

Boot's the Chemist at Westminster House in the new shopping centre on the day of its opening in November 1968, after the Mayor of Basingstoke had officially opened the area. When phase two of the shopping centre was completed in 1981 Boot's moved to a new and larger store in the Old Basing Mall. Boot's originally opened in Basingstoke in 1925 in London Street.

The Horse and Jockey in Hackwood Road was another of the many public houses to be demolished. The site now holds a row of old people's bungalows named after an ex-mayor, Councillor Harold Jackson. The houses on the right were also demolished.

Preparing the newspapers and magazines for distribution to the many local newsagents at Foyle's wholesale depot in Coronation Road in the late 1960s. Previously G. Stevens of 35 Church Street, the business had to move to larger premises when the Town Development Scheme increased the population of the town and more people wanted newspapers. Foyle's eventually sold out to John Menzies in 1993.

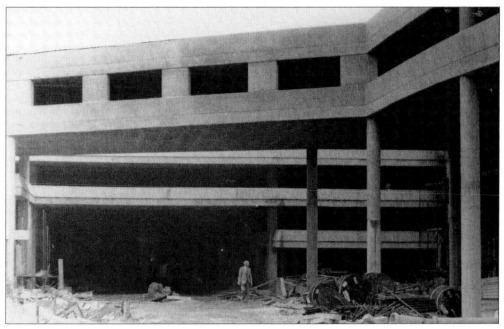

As the multi-storey car park was slowly built up tier by tier the local folk thought how ugly it was, and this view from the New Road end gives an idea of how it looked in the mid-1960s. Under the new plans to build an extension to the shopping centre this part of the concrete structure was demolished for an extension to the shopping centre in 1999.

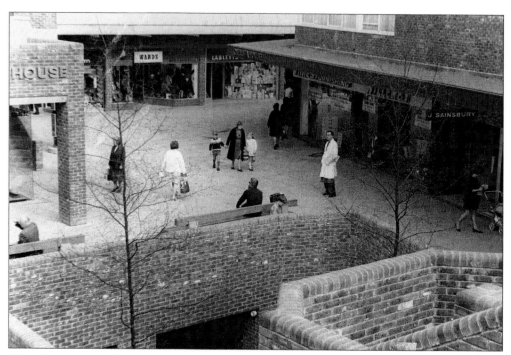

After the opening of the new shopping centre in 1968 there were second thoughts about the design and layout of the area. One particular eyesore, and danger to children, was the opening and stairs opposite Sainsbury's store in the first phase. On several occasions youngsters had been dragged back from the deep drop after climbing on to the benches next to the wall. Some years later it was decided to fill this space in, and this gave the public more room to walk through the shopping centre.

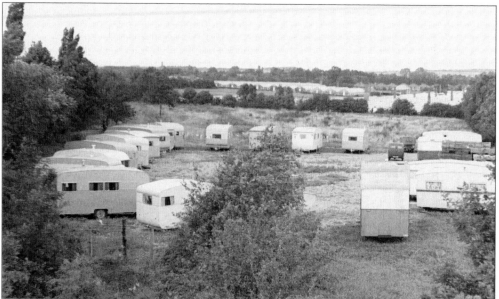

The Wessex caravan site, between Cranbourne Lane and the Basingstoke bypass, was another area affected by the Town Development Scheme. It was planned to build small industrial units there, but it was some years after the caravans were moved that this part of the scheme came into being.

Work taking place on the railway track at Worting during electrification of the line in early 1967. Ever since 1839, when the railway was opened between London and Basingstoke, steam trains had run along these tracks. Then on 10 July 1967 the last steam locomotive ran from London to Bournemouth, and from then on diesel and electric engines pulled the trains through Basingstoke.

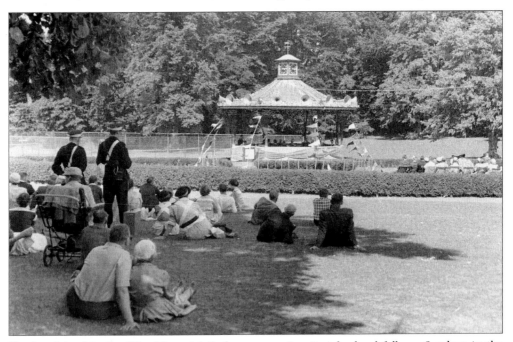

The bandstand in the War Memorial Park was an attraction for local folk on Sundays in the summer as various bands played their different melodies. The bandstand had originally been built for the Fairfields recreation ground but when the park was laid out for the public in 1921 the structure was moved to its present site. In July 2001 the bandstand was moved to a different position in the park, and the bands have since played every summer in Eastrop Park.

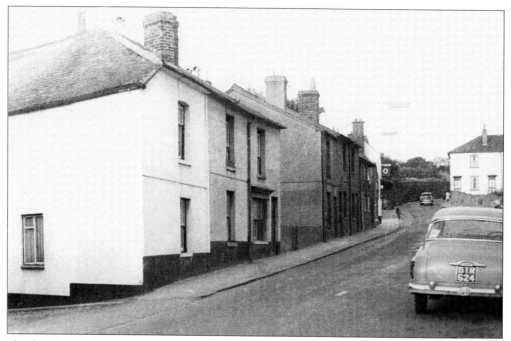

The demolition of the town centre stretched as far as Reading Road, where these houses close to the railway were pulled down. The Castle Inn in the distance is now the only building left in the road. This area was called Totterdown in Victorian times; the upper part of the road was known as the northern area, which became Norn Hill in later years.

St Mary's C. of E. church, Eastrop, in the 1960s, before alterations to its entrance from Goat Lane, and the construction of the new rectory and church hall. The old rectory, which dated back to 1757, was demolished in August 1970. The lych gate, erected in 1913, was also moved to a new site.

After the Plaza Cinema was closed in 1954 the frontage was altered, but the main part of the building was left to be taken over by the Basingstoke Co-operative Society as a furnishing store. The building was demolished to make way, with others, for the extension of the shopping centre.

When the Goat and Barge inns were closed and demolished it was thought that the names of these two very old public houses would be lost for ever. But a new public house, built close to the New Market Square, was given the name of the Goat & Barge in memory of them. But this did not last for long, for after some years the pub was renamed the Nightjar. The building was demolished in 1999 for the redevelopment of the shopping centre.

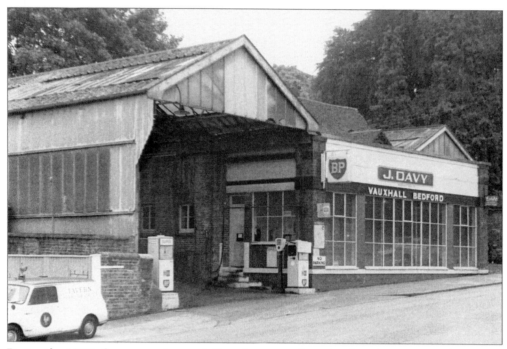

During the 1960s there were changes taking place away from the shopping centre, such as along the London Road, close to the War Memorial Park, where the Goldings Park Motor Company was taken over by J. Davy. In 1968 the garage was acquired by the Clover Leaf and demolished, to be rebuilt in a more modern style.

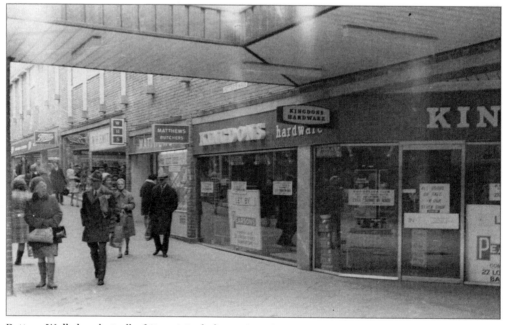

Potters Walk has lost all of its original shops since its opening in 1968. Some of them, such as Boot's the Chemist and W.H. Smith's, moved further down into the last phase of the centre, while places such as Kingdon's, pictured here, were taken over by other businesses, or closed altogether.

The Down Grange Cottages along Winchester Road, opposite Homestead Road, were threatened by the original plans of the Town Development Scheme and the residents prepared to be moved out before the cottages' demolition. The Brighton Hill housing estate was due to be built behind them, and a large roundabout was to be constructed close by, but nevertheless the cottages stayed put and are still there to this day.

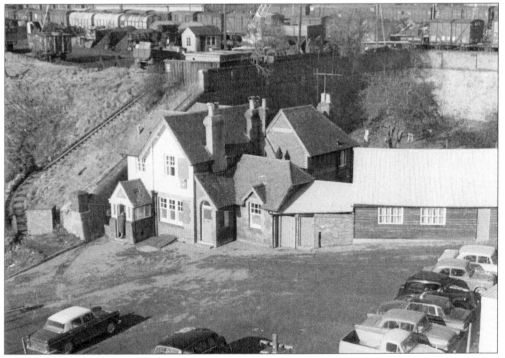

One public house that no one thought would be demolished was the Cricketer's Inn, tucked away between Brook Street and the railway. Unfortunately the authorities thought differently, and it closed down and was demolished to make way for the Victory Roundabout and Alencon Link in 1968.

The tall trees in Winchester Road, opposite Foulflood Lane, which is now called Hardy Lane, were an outstanding feature of that area, although the low branches did cause problems for high vehicles. In the late 1960s plans to build maisonettes on the site were approved, but many of the trees were allowed to remain after local people complained that to cut them down would be 'destructive'.

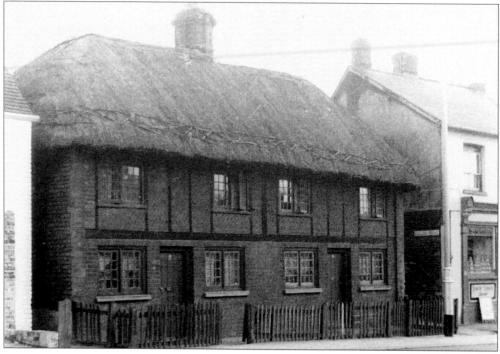

This cottage in Reading Road, now the site of the north side of Eastrop Roundabout, was the last thatched cottage in the town before its demolition in 1968. There were other thatched buildings in Chapel Street, just below the railway bridges, but these were pulled down at the same time.

The Member of Parliament for Basingstoke from 1964 through to the late 1970s was David Mitchell. He took an active part in local events both politically and socially, and in this picture he is cutting a cake at a social function at the Town Hall, with his wife giving him guidance.

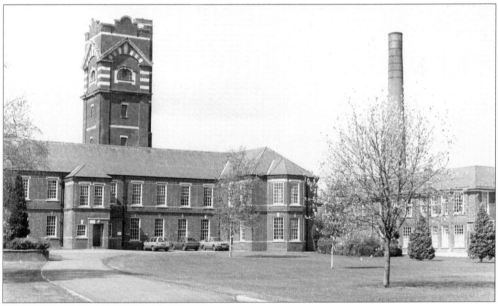

Park Prewett Mental Home, north of Basingstoke, was established during the First World War. In the 1960s it was a very well-run complex of buildings with the administration being carried out by a small group of dedicated people. Assessment of each person's mental ability was based on established rules and regulations, while social activities gave the residents a feeling of human understanding.

The Mighty Antar lorry, which was made by Thornycroft's factory in Worting Road during the 1960s. The company merged with the firm AEC Ltd of Southall during that time and became one of the ACV Group of companies. After Sir John Thornycroft moved his motor vehicle business from Chiswick to Basingstoke in 1898 the firm expanded to the extent that by the mid-1960s the works site was 63 acres in size. In 1968 the Leyland group took over the firm; then in 1973 Eaton's acquired the factory, closing it in 1991. The factory was demolished in 1995, to be replaced by a Safeway store. Safeway's was later taken over by Morrisons.

Opposite the Stag and Hounds public house in Winchester Road stood the Pied Piper restaurant and garage, both of which were run by Mr E.S. Talbot. By the 1970s the restaurant had closed down and the site was later taken over by Peter Green's furniture store. In 1985 it was demolished to make way for a large store for Habitat, to be replaced in more recent years by Staples, the office equipment and stationery business. The garage, meanwhile, was also demolished and rebuilt in a more modern style, with a filling station and shop.

In 1968 the Winklebury area, once known for its wildness and rough tracks, was slowly turned into a large housing estate with shops, schools, a church and other facilities. Before the land was completely taken over it was a haven for children to play on, with trees and shrubs for them to hide in. This photograph shows the area where Winklebury Six estate was built.

During the construction of the Winklebury estate many items of historical interest were found. During a playful rummage in the overgrowth two young boys, Antony Barker (left) and Paul Mills, found a rusty sword. They took it to a local historian who declared that it dated back to Napoleonic days, and that it was a soldier's bayonet.

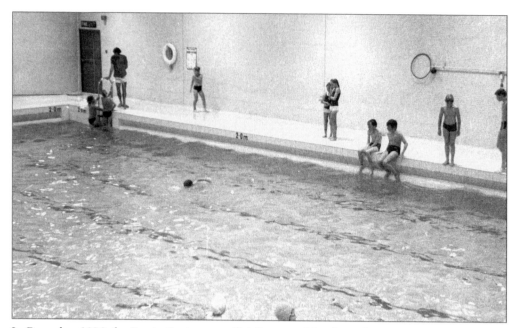

In December 1970 the Sports Centre was officially opened by the Duke of Edinburgh. One of the main features was the swimming pool, pictured here, which needed a filtering system: this was fitted with 'chimneys' built on the surface of the shopping centre. This led to a constant smell of chlorine in the air, and in November 1997 a massive chlorine leak led to an evacuation of the shopping centre for several hours.

The Sports Centre, built on the Church Street side of the shopping centre, was to give local people nearly every facility in indoor activity, including the use of trampolines in spacious conditions. In the background of this picture abseiling and climbing equipment can be seen. This photograph was taken shortly after the Sports Centre was opened.

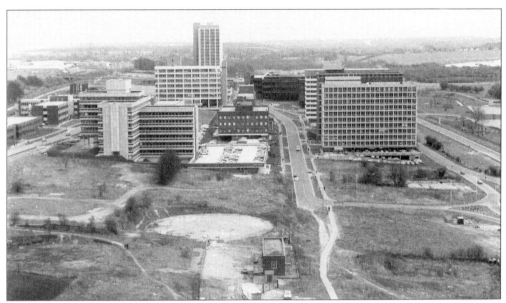

At the end of the decade the Eastrop business area was almost completed, with just a few sites waiting to be built on. What was once the old gasworks and local council town yard was slowly being turned into an area for offices where famous names such as Wiggins Teape and the Automobile Association would be established. In November 1973 the Queen arrived in Basingstoke to walk through the new shopping centre and then officially open the AA's building, which can be seen in the distance in this picture.

The completion of the first phase of the new shopping centre brought crowds of people from afar to spend their money. Christmas was to bring even more people into the town, and by the end of the decade sights such as this, with Christmas decorations, were to greet the folk as they walked along the malls.

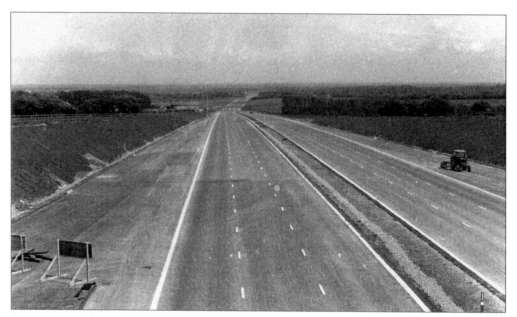

Construction of the M3 motorway at Dummer in 1970 after preparation work had been taking place in the previous year. In May 1971 it was opened to traffic. Part of the motorway runs through the private estate of Hackwood Park, and when purchase of the land took place in the late 1960s it was feared that the annual horse racing would have to cease – but another site was found.

The Old Castle Shop and Café in Victoria Street, with its adjoining garage, was a popular place for local folk in the 1950s and '60s, and its name gave rise to the story that a castle had once stood there. With Castle Field further up the road, close to Fairfields School, many people were convinced that such a structure did exist, but no records could be found that it did. The shop and garage were demolished to make way for the new telephone exchange in 1980.

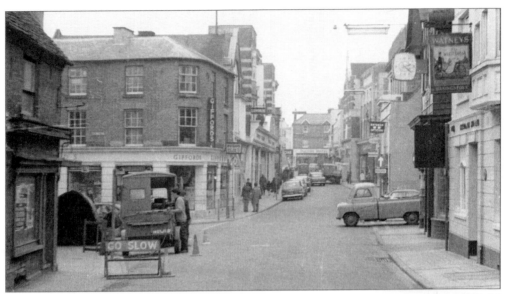

The decade saw many changes to the town because of the new shopping centre, but for the motorist passing through Winchester Street there was no sign of these alterations. The top of the town did not look any different to how it was years before, although there were a few subtle scenes which indicated that something was going on, such as these workmen preparing for new services to be fitted into the road. By the end of the decade the building on the right, the Victoria Hotel, was to close, to be changed into a discotheque in 1970; and the shop on the far left, which was owned by Mr A. Crate and closed in July 1965, was demolished in 1971. Traffic lights were erected on the crossroads in 1976.

In the 1960s this row of terraced houses was far from all the development going on at the bottom of the town, but within a few years this side of Southern Road was also to be demolished. This clearance was because of the construction of the New Road extension between Hackwood Road and Victoria Street, which meant that Webber's Garage would lose most of its workshops. Consequently it was decided to buy the land where these houses were and build new premises for the garage on that site; this took place in 1971.

Years ago Basingstoke was blessed with almshouses to house the elderly, such as the present Deane's Almshouses in London Street, but during the period after the Second World War many of these homes were closed down and demolished. One such place was Page's Almshouses, which was originally established in Hackwood Road in 1802 by Joseph Page. In 1930 the people were moved to new premises at the top of New Road, then again to the present site in New Road in 1975. The photograph shows the original building in Hackwood Road before its demolition for the New Road link with Victoria Street in the early 1970s. The doorway with BYP above it was the entrance for workers going into the Burberry factory, where raincoats and overcoats were made before the 1950s: the initials stood for Burberry's Yarn Proof.

One of the many bands that played at the annual carnivals in the War Memorial Park between 1956 and 1994. Funds from the carnivals were used for various purposes, especially for the construction of the Carnival Hall at Fairfields. Of all the events that took place during carnival week the Thursday procession was the most popular.

When the South Ham housing estate was extended across the fields to the Buckskin Farm area in the late 1960s, several rows of flats were built overlooking Kempshott. Twenty years later, in May 1987, the flats were demolished to make way for houses, because of the state of the buildings and the social problems caused by the closeness of the families living in these flats.

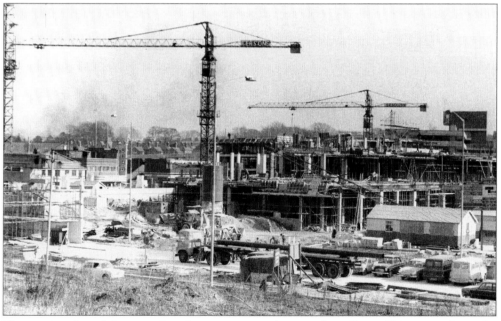

The construction of the new shopping centre gets closer to the railway. This scene shows the structure in the process of being built with the aid of two giant cranes. The lower part of Wote Street can be seen on the left of the picture. Construction continued throughout the 1970s to complete the project up to the railway station, and in October 1981 the last phase was officially opened by the Mayor, Councillor Roger Morris.

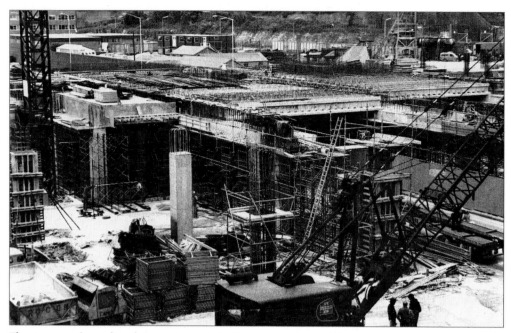

The masses of metal and concrete used in the construction of the new shopping centre can be seen in this picture, which was taken close to Churchill Way. On 7 February 1969 two men were injured when 60 tons of wet concrete, scaffolding and steel reinforcement crashed down during work on the shopping centre.

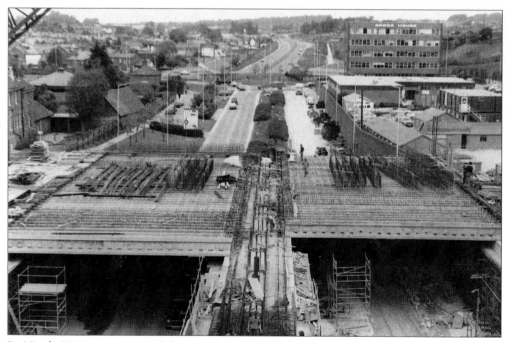

By March 1969 construction of the tunnel over Churchill Way was in full swing, and this involved a huge amount of metal and concrete. Huge girders were brought in to support the bridge and each one was tested for its strength, as both sides of the structure (over the two lanes of the dual carriageway) were to support a great deal of weight.

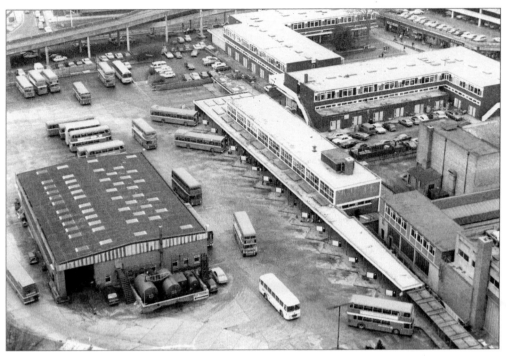

The bus station and the new Market Square in 1969. The bus station was built in 1962 with a depot in the centre of the site for maintenance purposes, but this was later demolished and rebuilt in the corner of the grounds to allow the huge Churchill Plaza offices to be built. In April 1991 a fire destroyed two floors of the Churchill Plaza and brought the bus station to a halt while firemen fought to control the blaze.

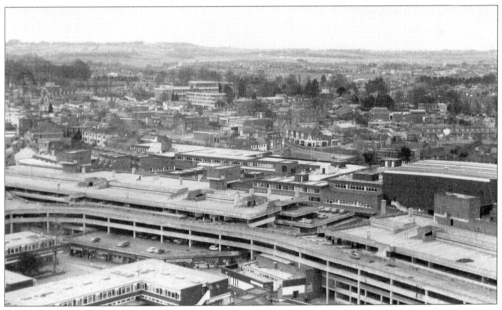

A general view of Basingstoke after the new shopping centre had been completed. In the centre of the picture is the old part of the town, while in the distance are the Farleigh hills. The multi-storey car park and part of the new shopping centre are in the foreground.

ACKNOWLEDGEMENTS

My main thanks go to Derek Joseph, who was manager of the *Southern Evening Echo* office in Basingstoke during the 1960s, and who gave me the opportunity to photograph and report on the various events of that decade, on a freelance basis. Without him many of these pictures would not have been taken.

Other people who have helped me in putting this book together by sharing their memories are: Mrs Joan Lawes, Sid Daly, 'Chubb' Dyer, John Finden, and many other folk who were associated with the town in the 1960s.

Visit our website and discover thousands of other History Press Books.
www.thehistorypress.co.uk